90 DEVOTIONS FOR

Women
On the Go

Pam Farrel &
Stephen Arterburn

Tyndale House Publishers
Carol Stream, Illinois

Visit Tyndale online at tyndale.com.

Visit Tyndale Momentum online at tyndalemomentum.com.

TYNDALE, Tyndale's quill logo, *Tyndale Momentum*, and the Tyndale Momentum logo are registered trademarks of Tyndale House Ministries. Tyndale Momentum is the nonfiction imprint of Tyndale House Publishers, Carol Stream, Illinois.

Designed by Eva M. Winters

Published in association with the literary agency of Alive Literary Agency, 5001 Centennial Blvd, #50742, Colorado Springs, CO 80949.

For information about special discounts for bulk purchases, please contact Tyndale House Publishers at csresponse@tyndale.com, or call 1-800-323-9400.

ISBN 978-1-4964-5075-3

Printed in the United States of America

27	26	25	24	23	22	21
7	6	5	4	3	2	1

To Robin, for praying me through.

*To my Young Women of Influence group: mentoring
you brings me joy, hope, and the promise that God is
passing the baton of faith securely to the next generation.*

*To all my fellow "on the go" friends who read
this book: May God meet you as you read it in
the same way he met me while I wrote it!*

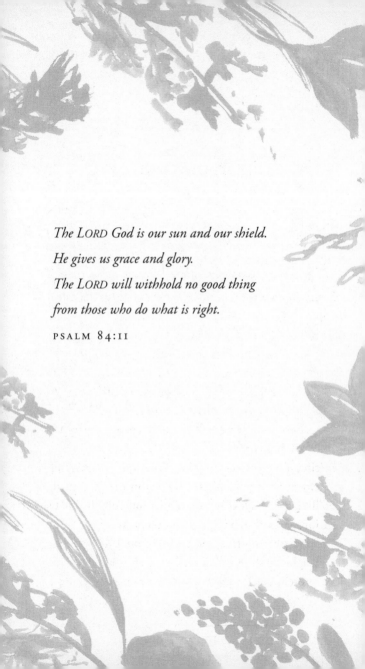

The LORD God is our sun and our shield.
He gives us grace and glory.
The LORD will withhold no good thing
from those who do what is right.

PSALM 84:11

Introduction

YOU LOOK AT YOUR WATCH—NO TIME! You look at your to-do list—no time! Does everyone seem to want a piece of you? Does it seem as if the more you give, the more people want from you? Do you wonder how you can give any more or go any more? Has your "get up and go" gone? If so, this devotional is for you. It is for any woman who wants to grow in a relationship with God and go through her busy, on-the-go days with God.

Within its pages you will discover timeless truths from God's Word that will revive, restore, reenergize, and renew you; principles to help you cope with crushing circumstances and nagging irritations; suggestions to help stabilize your life for success in the long haul. You'll also find ideas for strengthening your intimate relationship with God and with others, as well as ways to cope with emotions and fears common to women. You might think of the devotions as spiritual vitamins or a protein bar for producing character on the run. I

know this because I wrote them on the go: my days are filled with speaking schedules, family obligations, writing projects, and my ministry, Seasoned Sisters.

God is so personal. He meets us where we are: waiting for kids at soccer or ballet practice; dragging home bone-tired at the end of a rugged workday, or rushing out the door for the daily commute. Our full schedule doesn't affect his presence with us. He is right there, just waiting for us to carve out a few minutes so that he can give us a glimmer of hope or a nugget of wisdom from his Word.

Tuck the *90 Devotions for Women on the Go* in your glove compartment, your briefcase, your purse, your desk, or your nightstand. Make a commitment to God that you will give him at least five minutes every day. He longs to give you rest and refreshment, and he promises to meet you wherever you are—even on the go!

Pam Farrel

To Read: Proverbs 2:1-11

First Things First

Tune your ears to wisdom, and concentrate on
understanding. . . . Then you will understand what it means
to fear the LORD, and you will gain knowledge of God.
PROVERBS 2:2, 5

SOMETIMES on our daily path in our relationship with God, spending time with him can seem like just one more thing on an already long to-do list. With responsibilities that seem to keep us unendingly on the go, it's easy to lose perspective about exactly why we *need* to spend time in God's Word daily. And yet God's Word itself promises wonderful benefits to those who will take the time to pursue wisdom:

> My child, listen to what I say, and treasure my
> commands. Tune your ears to wisdom, and
> concentrate on understanding. Cry out for insight,
> and ask for understanding. Search for them as you
> would for silver; seek them like hidden treasures.
> Then you will understand what it means to fear the
> LORD, and you will gain knowledge of God. For

the LORD grants wisdom! From his mouth come knowledge and understanding. He grants a treasure of common sense to the honest. He is a shield to those who walk with integrity. He guards the paths of the just and protects those who are faithful to him.

Then you will understand what is right, just, and fair, and you will find the right way to go. For wisdom will enter your heart, and knowledge will fill you with joy. Wise choices will watch over you. Understanding will keep you safe.

PROVERBS 2:1-11

Doesn't this seem like a great deal? If you have spent years second-guessing yourself, the wisdom in God's Word builds confidence in decision making. If you have felt like a victim in some aspect of your life, God's Word is a shield, and God is your protector. If you are depressed, God's Word gives comfort and knowledge that are pleasant to your soul. If you are struggling with the consequences of unwise or foolish choices, God's Word can teach you discretion that will protect and guard you from this point forward. Considering all the benefits of gaining God's wisdom, our busy days will go much more smoothly once we have God's wisdom firmly in our minds and hearts.

To Read: Philippians 3:12-14

Eye on the Goal

*I press on to reach the end of the race and
receive the heavenly prize for which God,
through Christ Jesus, is calling us.*

PHILIPPIANS 3:14

I WAS A COMPETITIVE GYMNAST growing up. To perform a medal-winning beam routine, I had to keep my eyes on a fixed point ahead to keep my balance. To look down or look away would mean a fall. The apostle Paul understood this, so he encouraged those in the persecuted church to "fix [their] eyes not on what is seen, but on what is unseen" (2 Corinthians 4:18, NIV). And the writer of the book of Hebrews said, "Fix your thoughts on Jesus" (Hebrews 3:1, NIV), and "[Fix] our eyes on Jesus" (Hebrews 12:2, NIV).

In these verses the word *fix* means "to reach a goal or look attentively at the goal in front of you."

Picture it! Cut out pictures of the goal. If you are raising funds for a project, keep the renderings in front of your desk. If you have a goal of writing, print out

the best-seller list from the *New York Times* website and hang it on the refrigerator. If you are losing weight, put up pictures of the outfit you'll wear when you reach your goal. If you are trying to get out of debt, make a graph so you can see your progress.

Chart it! Plan out step-by-step how you will attain the goal. I use a chart that looks like a set of stairs. I put the long-term goal at the top of the stairs, then I break it into smaller steps with due dates for each step.

Write it! Place motivational, inspirational quotes all over your mirror, on your desk, any place where you will see them. Choose your favorite verses, those that give you emotional and physical strength.

Think it! Create your own motivational prompts, or listen to podcasts and sermons from the leaders who inspire you to excel.

As you focus on your goal, you will see your success as well.

To Read: 2 Peter 3:13-18

Progress to Perfection

Grow in the grace and knowledge of our
Lord and Savior Jesus Christ.

2 PETER 3:18

CARISSA HAS COME A LONG WAY. She has overcome being abandoned by her birth mother and stepmother, the drug-overdose death of her father, and abandonment by her first husband. But she still avoids driving mountain roads—too scary!

Skye has experienced life-changing faith that turned her from a former free spirit into a serious parent and teacher, but she is still afraid to fly.

Sandy is a strong leader, a role model to younger Christian girls, and a Bible teacher, yet she feels weak at the knees if she's asked to speak in front of a large group.

Renee used to be afraid of leaving her home, meeting new people, and making phone calls—people basically freaked her out. Now she is out of the house for work and church, but she still feels her chest tighten when she's forging new relationships. Small talk is fine, but

somewhere in each new friendship she has to fight the impulse to run away.

Works in progress. Why do we feel that if we are not perfect, we are a failure or "less than" another person in spirituality or emotional health? Romans 8:1 proclaims, "There is no condemnation for those who belong to Christ Jesus." Condemnation means there is now no adverse sentence.

Quit overreacting to your shortcomings. Let's give a new definition to emotional well-being: progress. Movement, not perfection, should be your goal. Next time you are feeling guilty that you are afraid to drive in traffic or don't want to fly alone, call one of your less-than-perfect friends, own up to the fear, ask for prayer, refuse the guilt, and walk forward knowing there is a whole team of imperfect people—in fact all of humanity—backing you up.

To Read: 2 Timothy 2:1-10

Keep Going!
You Can Do This!

You have heard me teach things that have been confirmed
by many reliable witnesses. Now teach these truths to other
trustworthy people who will be able to pass them on to others.
2 TIMOTHY 2:2

WHEN A YOUNG MOTHER, Ariel, called needing some advice and encouragement, part of my advice was to reconnect her to Michelle, an older woman who had discipled her when she was a high schooler and college student. The strand of faith was passed from one to another to another, generation to generation.

Many times when you are trying to walk the straight and narrow, the road seems hard and the mountain steep, and you need to hear the reassuring voices of those who have made it to the top. You need to hear, "Keep going! You can do this! It's worth it!"

Soon after my conversation with Ariel, the phone rang again. It was Michelle, calling to thank me for being like a spiritual mom to her. When Ariel told her I recommended she call Michelle, Michelle had been reminded of the benefit of connecting one generation

to another and passing on the baton of faith. I had mentored Michelle, and Michelle had mentored Ariel, so I had a connection to Ariel, too! The connection has remained intact over years and miles.

We all need connections. To those who are older, Psalm 145:4 directs us: "One generation commends your works to another; they tell of your mighty acts" (NIV).

Conversely, those younger in the faith need to find someone who will tell them of the mighty acts of God. Make a list of five to seven women you would trust with your heart: women who will encourage you, strengthen you, and tell you God's truth. If you can't think of seven women to call, then call one and ask her to connect you to someone who will disciple you. Create a success network by learning from those who have gone before and then passing the baton of belief forward.

To Read: Matthew 5:21-26

Close the Gate behind You

If you are presenting a sacrifice at the altar in the
Temple and you suddenly remember that someone
has something against you, leave your sacrifice there
at the altar. Go and be reconciled to that person.

MATTHEW 5:23-24

I GREW UP ON A FAMILY FARM. I was often assigned the job of helping move either the cattle or sheep from one pasture to another. My whole job was to close the gate behind the herd so they couldn't backtrack and get into a field of alfalfa. All I had to do was close the gate behind me. Sounds simple enough, right?

But gate closing is boring work. Gate closing is a whole lot of waiting until something happens. Gate closing isn't prestigious or exciting, but it is vitally important.

On the path to wellness, wholeness, and emotional health, there are many gates to close. There are groups to attend, homework to complete, and amends to make. Closing the gates means not leaving loose ends hanging. Are there some people with whom you have some loose ends? Is there a phone call you need to make to

say, "I'm sorry"? Do you need to return something that you "borrowed"? Is there restitution that might renew a relationship?

My mama used to tell me, "Close the gates behind you." And most often she wasn't talking about the field gate, but rather making amends to repair or restore a relationship. Jesus was so serious about the need to make things right that he told people not to give a gift to God unless they first made things right with others (see Matthew 5:23-24).

Pray and ask God to remind you of open gates in relationships that may need to be closed so you or another can gain freedom to move forward.

To Read: Psalm 26:1-12

Listening to God

I am always aware of your unfailing love.
PSALM 26:3

OUR RELATIONSHIP WITH GOD requires a listening heart. We need to make the same commitment that David did in Psalm 85:8: "I will listen to what God the LORD says; he promises peace to his people" (NIV). So what can you do while you listen?

Think: Research the issue. Do a topical study. Write down your questions, your dreams, and your ideas. Then take the key words and phrases, look them up in a concordance, and seek to find the heart of God through his Word.

Pray: Talk to God about your dreams, ideas, fears, or habits. Talk to him about your successes and frustrations. Tell him your hopes—and hang-ups. Find a time and place to pray. Start a prayer journal and log your requests, key verses to pray, your impressions, and the thoughts and ideas you sense may be from God. Weigh

your impressions against the truth found in the Word of God. You might listen to an audio Bible to create a backdrop of truth in your heart.

Walk: Exercise. Creative juices flow after physical activity. Endorphins release ideas, so get out and about. Move, dance, run, ride a horse, cycle, or kickbox out your frustrations—but move! Physical movement makes white space in the mind. For example, when I swim in a pool, I can pray through my life without interruption. When I swim in the ocean, my problems nearly disappear as I concentrate on the rhythm of the waves.

When you fall in love, you make dates that allow for conversation. The same is true with your relationship with God. Make some space in your life to listen to his Word.

To Read: Matthew 6:25-34

Right on Time

I tell you not to worry about everyday life—whether
you have enough food and drink, or enough clothes to
wear. Isn't life more than food, and your body more than
clothing? . . . Seek the Kingdom of God above all else, and
live righteously, and he will give you everything you need.
MATTHEW 6:25, 33

SOMETIMES YOU'RE SURE about what God wants you to
do, but movement seems slow and hard.

When my husband, Bill, and I were called into the
senior pastorate from youth ministry, there were about
six months in between when Bill ran his own business.
We didn't have a large savings account, and when clients
were late paying their bills, we were between a rock and
a hard place. I put a list of "needs" on the refrigerator:
grocery items, electric bill, gas for the car, etc. Each day
I'd pray, "Give us each day our daily bread" (Luke 11:3,
NIV). I realized that I expected God to provide ahead of
time, instead of day by day. I was secure only if I could
see money in the bank.

While I believe that Proverbs clearly teaches that the
wise save for a rainy day (see Proverbs 6:6-8; 21:20),
sometimes life's storms last longer than the savings. I

13

began to pray, "Lord, help me not feel the need, until it is a need." And, "God, give me faith to believe you will provide right on time." Some days I prayed, "Just let me go one more day and trust your provision." I prayed verses like Psalm 37:25: "I was young, and now I am old. Yet I have never seen the godly abandoned or their children begging for bread." And if things felt really tight, "Lord, help me make it one more hour, with my focus on you, not the need!"

I kept a journal of God's provision. The unexpected job that paid cash, the diaper rebate check that bought milk the day we ran out, etc. God provided what I *needed* right on time.

To Read: Philippians 4:4-9

Hide and Seek

*Fix your thoughts on what is true, and honorable,
and right, and pure, and lovely, and admirable. Think
about things that are excellent and worthy of praise.*

PHILIPPIANS 4:8

KRISTA HAD EXPERIENCED IT ALL: drug and alcohol
abuse, promiscuity, and the death of her mother. Her
past could have defined her future, except she decided to
go on a women's retreat. As Krista entered an empty cha-
pel, God's Holy Spirit swept over her so powerfully that
she fell to her knees and wept a host of cleansing tears.

"Satan tried to attack me—but I fought back with
obedience: attending church weekly, daily reading of
God's Word and prayer, attending a care group, tithing,
and serving others. Philippians 4:8 became my strong-
hold, and I made sure that everything I heard, read, or
watched was 'worthy of praise.'"

Are you using obedience to fight back attacks? Are
you guarding your heart and life by choosing praise-
worthy activities and interests? Why obey? Psalm 103:17-
18 says, "The LORD's love is with those who fear him,

and his righteousness with their children's children—with those who keep his covenant and remember to obey his precepts" (NIV).

Ask yourself, *If I were introduced to Jesus at a party this week, could I brag about: What I have seen? What I have heard? What I have done?*

One of the early warning signs that your choices may be off is that you feel you can't share your choices with family members, your pastor or other spiritual leaders, or friends who love God. If you can't be excited about your choices around them, check to see if the choice was "worthy of praise." If you feel you have to hide something you have read, watched, or done, then confess your poor choice to God and go immediately to the person you might be hiding it from and ask for help.

Don't play hide and seek—instead seek help and hide nothing.

To Read: Isaiah 43:1-7

I Will Survive!

When you pass through the waters, I will be with you;
and when you pass through the rivers, they will not
sweep over you. When you walk through the fire, you
will not be burned; the flames will not set you ablaze.

ISAIAH 43:2, NIV

"PASTOR, MY HOUSE is burning to the ground!"

The firemen tried desperately to save her home, but to no avail. Bill had called me en route, and I offered to help in any way I could. Later that evening, about 10 p.m., I got another call from Bill. "Honey, Marjorie only has the clothes on her back, and she wants to know if you'll take her shopping."

I drove Marjorie to our local discount store, and I was so impressed with her frame of mind on such a catastrophic night. As we walked to the checkout, something on our faces must have given a clue to our emotional state. The checker said, "Cheer up! It's almost Christmas! It can't be that bad."

I replied, "It can be. My friend's home burned to the ground today."

In silence he rang up the purchases then reached

across and touched Marjorie's hand. "Ma'am, I am so sorry. I will pray for you."

That gesture of care meant so much to my friend Marjorie. As we stepped out into the cool, crisp Christmas air, Marjorie said, "Pam, in the end, the Bible says everyone's stuff will burn—mine just went up sooner than yours!" Then she smiled.

I was amazed at her courage. Then she added, "It's just stuff. I've survived worse. I'll hang on to God, and I'll survive."

Marjorie, a woman whose husband beat her and then left her for another, whose only son was killed in an automobile accident, and who had poured herself into a successful career only to watch it crumble months before her retirement, instinctively clung to Jesus when her house burned.

Hold on to Jesus—you will survive!

To Read: Ruth 1:1-22

The Return

So Naomi returned.

RUTH 1:22

NAOMI WAS IN A DOWNWARD SPIRAL: Her husband had died. Her sons were dead too. She had been living for years in a foreign land where few worshiped God.

Now she had two daughters-in-law to provide for, and she felt she couldn't even care for herself. She was in an emotional and spiritual famine. Naomi was so depressed she even changed her name. "Instead, call me Mara, for the Almighty has made life very bitter for me" (Ruth 1:20).

She knew if she stayed in this barren place, she would die. And if she didn't make provisions for her daughters-in-law, they might die too.

Naomi made a pivotal decision. She must go back to the place she knew she would hear the voice of God again, to her home in faraway Bethlehem, even if she had to walk each step of the way alone. Naomi knew

she needed to return to a place where there was not only food for her body but also food for her soul. The first step out of this depression was to go where she would receive good counsel and care.

When we find ourselves in the deserts of life, we need to go back to the people and places that first helped us hear and learn about God. Going back to those who we know will give us healthy wisdom is not a step backward; rather, going back is often the first step in going forward again.

Who are the people, what are the resources that first gave you healthy teaching about God and emotional wellness? It is not failure to return or retrace the steps that made you well the first time. Going back will move you forward.

To Read: Ruth 2-3:11

A Life God Can Reward

Now don't worry about a thing, my daughter.
I will do what is necessary, for everyone in
town knows you are a virtuous woman.

RUTH 3:11

HOW CAN YOU LIVE A LIFE God can reward? Let's step
into the story of Ruth.

Boaz, a godly, rich landowner, sees Ruth and com-
ments to her, "May the LORD, the God of Israel, under
whose wings you have come to take refuge, reward you
fully *for what you have done*" (Ruth 2:12, emphasis
added). What had Ruth done? Let's see what five things
Ruth did to live a life God could (and would) reward.

Be with quality people. It started when Ruth left
her pagan ways and joined her mother-in-law, Naomi,
on her trek back to Israel, after Ruth's husband died.
Then once there, they had to find a way to get food, so
Naomi directed Ruth to Boaz's fields so she could glean
safely. If you are new to a community, or if you want
to improve your friendship circle, find quality people at

churches, service groups, Bible studies, seminaries, or self-improvement classes.

Be a hard worker. In verse 7 there is a comment on how Ruth had been "hard at work"—doing field labor! This was backbreaking work. When people see your work ethic, they want to help. When God sees it, he is moved to reward you.

Be humble. When Boaz called Ruth over, "she bowed down with her face to the ground" (verse 10, NIV). God promises that if we humble ourselves under his mighty power, he will honor us at the proper time (see 1 Peter 5:6).

Be yourself. Boaz invited Ruth to lunch, and "she ate all she wanted" (Ruth 2:14, NIV). She didn't put on airs and pretend she wasn't hungry because she was on a date! Ruth was real.

Be generous. Ruth always took food home to Naomi. In fact, Ruth cared for Naomi in such a way that Boaz said to Ruth, "Everyone in town knows you are a virtuous woman" (3:11).

To Read: Joshua 23:6-11

God's Statements of Love to You

Be very careful to love the LORD your God.
JOSHUA 23:11

A RELATIONSHIP with God is possible. Look at his statements of love to you:

I love you and have a plan for you:

> My purpose is to give them a rich and satisfying
> life. (John 10:10)
> This is how God loved the world: He gave his
> one and only Son, so that everyone who believes
> in him will not perish but have eternal life. (3:16)

I know you are imperfect, so you are separated from my love; our relationship is broken.

> We've compiled this long and sorry record as
> sinners . . . and proved that we are utterly

incapable of living the glorious lives God wills
for us. (Romans 3:23, MSG)

I love you, so I, who am perfect, paid the price for your imperfection in order to restore our relationship.

God showed his great love for us by sending
Christ to die for us while we were still sinners.
And since we have been made right in God's
sight by the blood of Christ, he will certainly
save us from God's condemnation. For since
our friendship with God was restored by the
death of his Son while we were still his enemies,
we will certainly be saved through the life of his
Son. (Romans 5:8-10)

To initiate this new relationship, all you need to do is to accept my payment for your imperfection. I cannot make you love me; that is your choice.

If you openly declare that Jesus is Lord and
believe in your heart that God raised him from
the dead, you will be saved. (Romans 10:9)

The word is out: God loves you. Want to tell God you love him?

To Read: Psalm 37:1-7

Give God Time

Be still in the presence of the LORD, and
wait patiently for him to act.
PSALM 37:7

ON THE SAME DAY, two women called me. Their names were different, but their stories were nearly the same.

Both had husbands who were inattentive to their needs. Neither husband was helpful in parenting their young children or working around the house. Both felt their dreams were being crushed. Both felt devalued. Neither was abused in any way. Both were in a midlife transition of their own, trying to find themselves and blaming their husbands for their own discontent.

My advice was the same: "Focus on your own growth. Don't wait for your husband to be your cheerleader. He might not be able to do that because of issues in his own life. Pray and ask God to meet your needs. Also start praying for your husband. For the sake of your children, don't just abandon the relationship. Pray and give God time to work."

A year later I got an email from one of the women. She had ignored my advice, left her husband and children in the middle of the night, and fled to the arms of a lover. Now she was in a huge custody battle for her children. By her own admission, her children were now unhappy because she had chased a dream for happiness.

A few weeks later the other woman called. She relayed her own journey: "I was looking to my husband to meet a need only God could fill. As I let God redefine me and remake me, I found my husband was really a pretty nice guy after all. My kids are doing so great—probably because I'm not such a control freak anymore!"

This woman now helps other women find contentment in God alone. Statistics say that when couples experiencing great marital discord stay together even if they don't "feel" happy, within five years they rate their marriage as happy or very happy.

Give God time.

Replay

Guard me as you would guard your own eyes.
Hide me in the shadow of your wings.

PSALM 17:8

TERESA FELT AS IF A DARK CLOUD were following her around. But why? From the outside her life seemed wonderful. She had a kind husband and two excelling children.

Each day brought mail with more good news—so why was she feeling a sense of doom? She felt like she was going to collapse with a mix of contrasting emotions: anger, frustration, depression, panic, and hopelessness for herself and her family. She knew she couldn't keep living this way. Her family couldn't deal with her being this way. Something had to change—or someone had to change.

It's not unusual to sense anxiety when your child is approaching the age you were when some traumatic event or abuse may have happened in your own life. Unchecked, your actions and feelings will become more

overstated, and you will feel out of control. If people who love you are asking you questions like, "What is up?" "Why are you overreacting?" those can be signals that the problem isn't with your spouse, your child, or even your life, but with you.

If it feels like the black clouds are rolling in, and you're afraid of the coming storm, what's the first step out of the rain? Take shelter from the fear by investing in resources to broaden your view of God. The bigger, stronger, more loving, and more able you are to see God, the smaller your sense of doom and gloom will become.

Is there something in your past that could be impacting your future? Knowing that fears might be ahead will help you prepare. Step out of the storm and under God's wings of care.

To Read: Leviticus 25:1-7

Sabbatical

During the seventh year the land must have a Sabbath year
of complete rest. It is the LORD's Sabbath. Do not plant
your fields or prune your vineyards during that year.

LEVITICUS 25:4

ISRAEL WAS COMMANDED by God to take a Sabbath rest
every seven years. Instead of planting and harvesting,
the people were to spend the year in rest, reflection, and
restoration.

A Sabbath break can be welcome time off to rest
physically, emotionally, and socially. By setting aside
time that would have been filled by the regular ebb and
flow of our daily routines, we can replenish our lives.

Professors often take a semester off to travel or do
research. A few fortunate pastors have churches that
invest in sabbaticals so they will gain more to give.

After my father passed away, I took a minisabbati-
cal from my ministry responsibilities for several months
because I needed time to process my grief and handle
other responsibilities with my family. Some of my
friends in leadership have planned extended times of

rest during career transitions. Some families have built periods of rest and replenishment into their lives yearly, setting up summers off or at least working part-time and planning a change of location: cabins by the lake, a few weeks at summer camp, or a month in the country.

If you are feeling worn out, get out your calendar and budget, and figure out how you can take time for rest and relaxation. However, a true sabbatical isn't just a vacation; rather, it is a plan for restoration and replenishment.

Worship, study in the Word, time with positive people, and quiet moments of reflection, contemplation, and prayer should all be included. A sabbatical isn't dropping out of life; rather, it is dropping into God's presence so you can gain a better, stronger view of your life. By taking time to care for yourself both physically and spiritually, you will feel stronger for the journey ahead.

To Read: Ephesians 3:14-16

Struggles That Define

*I pray that from his glorious, unlimited resources he will
empower you with inner strength through his Spirit.*

EPHESIANS 3:16

"IT IS OUR STRUGGLES THAT DEFINE US," my friend
Donnie said to me.

Think of some of the heroes of the faith: Abram
was called to move "to the land that I will show you"
(Genesis 12:1). This was a struggle to walk by faith not
sight. God renamed him Abraham, and he is known
as the father of three religions: Judaism, Islam, and
Christianity.

Joseph was sold into slavery by his brothers, a
struggle of the ultimate betrayal. Yet he forgave his
brothers, and God rewarded him with the post of
Egypt's second-in-command.

Daniel, a slave, struggled to worship the true God—
but he did. He was thrown into a den of lions and lived
to tell about it.

Esther, a queen, struggled, knowing that her people

were about to be annihilated. Only she could risk walking into the king's presence and asking for mercy. Her statement of courage, "If I perish, I perish," has gone down in history.

Naomi was a widow struggling for survival for herself and two daughters-in-law. She didn't know how they could all live. In the end her decision to return to Bethlehem gained her economic survival, a precious relationship with Ruth, a new son-in-law, and a new grandchild in the messianic line.

What is your struggle? Can you see how God is defining you and his work in your life through it? Cling to him, and he will bring you to the other side.

To Read: Hebrews 12:1-4

It's All about Me

We do this by keeping our eyes on Jesus, the
champion who initiates and perfects our faith.
Because of the joy awaiting him, he endured the
cross, disregarding its shame. Now he is seated
in the place of honor beside God's throne.

HEBREWS 12:2

"I NEVER GET TIME FOR *ME*. . . . I thought it was time
to spend money on *me*. . . . I deserve something
for *me*. . . . I needed to have the plastic surgery for
me. . . . No, I can't come to Bible study—I need to
do more for *me*. . . . It is *my* turn. . . . I need to find
myself."

Me, myself, and I. When I start hearing those words
repeated in every conversation I have with a woman,
I fear she is headed for disaster. It is interesting that
selfishness is translated "strife" in the KJV, and in Greek
it means "contention." Nothing good comes to mind
with those words!

While it is important and necessary that a woman
discover her gifts, use her talents, and understand who
she is, too many women turn to self-centered pursuits
on their journey of discovery. The danger in making

life "all about you" is that you will often succeed. A life that is egocentric—centered on fulfilling your hopes, dreams, and goals regardless of the price—becomes an empty life.

Your husband may patiently endure, but his heart will detach emotionally. Your children, no matter their age, will pick up on the vibes that you and your needs are a higher priority than they are and their needs. Soon they, too, will look for others to meet their emotional needs.

A woman who thinks she can solve her emotional pain by turning inward is a woman on a lonely journey. Friends, family, and coworkers will get your message loud and clear: *Leave me alone. Let me live my life!* They will let you, and your world will shrink down to one.

Take your pain, questions, and need for personal space or identity and look up, not in. God will answer your heart cry. Listen to yourself this week. How often do you hear, "Me, myself, or I?"

To Read: Isaiah 26:1-6

Thought Control

*You will keep in perfect peace all who trust in
you, all whose thoughts are fixed on you!*
ISAIAH 26:3

DETERMINATION IS A KEY INGREDIENT in living out our
dreams. But some days it seems everything goes wrong!

At those moments when bad news arrives or my
plans come to a screeching halt, my natural reaction is
anger, fear, or depression. If life were a movie, dark fore-
boding music would be playing in the background to
heighten the already strong sense of impending doom!

At those moments it is easy to believe Satan's lies:
"You're going to fail. This will never happen! What were
you thinking?"

Instead, I choose to take the thought captive and
put the bad news in perspective. What's the worst-case
scenario? Usually it is inconvenience more than failure.
Then I also ask, "Is God still in control?" Looking to
the many verses that declare God is sovereign Lord or
supreme Deity, I can say the obvious answer is yes!

Then I ask, "What help is available to help me?" I don't usually have a clue, but God is wise. I am afraid of failure, but God is perfect and never fails. I may be without resources, but God created and owns everything.

As I recall the truth about God and review his strengths, I am forced to think thoughts beyond my own. That process helps me think differently. New, better, and even creative thoughts and options begin to appear.

And peace comes—and with it the ability to think more clearly.

To Read: Psalm 122:1-9

The Pity Party

All the tribes of Israel—the LORD's people—make
their pilgrimage here. They come to give thanks
to the name of the LORD, as the law requires.

PSALM 122:4

ON THE WALL IN MY KITCHEN is a sign that is six feet long. It says: Thou Shalt Not Whine. My kids think it's there for them, but it's really there for me. Serving women for more than thirty years and being a woman myself, I know how easy it is to fall into a pity party.

When days get blue, one of the things I like to do is read about women who have gone before, those with great odds to overcome. I especially like to read about women who came west, selling nearly all their possessions, packing up their children, and braving the hard, long trails. Many of these women lost children to disease, the enemy, or wild animals. These brave women then held down the frontier: cooking, baking, washing, and sewing with the most primitive of tools in dugout homes made of sod.

At first these pioneers staked their claims a great

distance from one another, but soon the settlers learned that when they built their homes on adjoining properties, neighbors were close enough to gather for quilting, canning, and the birthing of babies. The pity party seemed to turn into a time of rejoicing as women shared their lives and supported one another.

Look at the early church's example: "All the believers were together and had everything in common. . . . Every day they continued to meet together in the temple courts. They broke bread in their homes and ate together with glad and sincere hearts" (Acts 2:44, 46, NIV).

Loneliness feeds the whining—friendship divides the sorrow.

To Read: Psalm 119:41-48

Where Have You Been Walking?

*I will walk in freedom, for I have devoted
myself to your commandments.*

PSALM 119:45

WHEN I WAS A YOUNG GIRL about eight years old, I walked
to and from church because I just wanted to be where
God "lived." I'd silently slip into the main sanctuary, sur-
rounded by light streaming from the stained-glass win-
dows. My feet would slide quietly over the deep burgundy
carpet as I inched my way up to the front pew so I could be
near the big white Bible that lay open on the Communion
table. I didn't care that I had to walk blocks and blocks to
get to church. It was peaceful there, and I felt as if heaven
smiled on me each time I entered. I learned many truths
there, including one found in a simple Sunday school
song: "Be Careful Little Feet Where You Go."

As I grew up, I began to realize how easy it is for
women to walk away from what is true, right, and healthy
and how easy it is to walk toward what is wrong: wrong
man's arms, wrong bar, or wrong party.

Some steps away from the truth are more subtle: spending more and more time with a persuasive friend who doesn't acknowledge Christ or his principles; reading posts on social media that make me feel inferior about my body; listening to songs that glorify casual sex; or even walking to the beach instead of church on Sunday morning.

Our prayer should be: "Teach me your way, LORD, that I may rely on your faithfulness; give me an undivided heart, that I may fear your name" (Psalm 86:11, NIV). And the result: "I will walk about in freedom, for I have sought out your precepts" (Psalm 119:45, NIV).

Retrace your footsteps over the past few days. Where have you been walking? Where would you like to walk?

To Read: Proverbs 27:17-23

You Gotta Have Friends

As iron sharpens iron, so a friend sharpens a friend.
PROVERBS 27:17

"WOULD YOU LIKE TO BRING a few of your healthy friends to the next meeting?" I asked.

"Healthy friends? What do you mean?"

"Do you have one or two friends who encourage you to make wise and godly choices? Positive people who believe in you, want the best for you?"

She stared back at me, drawing a total blank, and then she flatly responded, "Um, no. I don't think I do."

What a shame! It is really true that misery loves company and "bad company corrupts good character" (1 Corinthians 15:33). People of severe dysfunction seem to be magnets for people with severe dysfunction.

Often when a woman desires to change her life, she may have to go outside her friendship circle to find help and support. Developing new, healthier friendships can feel a little frightening, especially if you are still battling

old ghosts from your life and lies burned into your thinking. Lies like, *You aren't good enough, smart enough, or pretty enough.*

How can you battle past the lies and gain some healthier friends?

Hang out where healthy women hang out: Bible studies, support groups, career enhancement organizations, parenting classes, or places of education.

Meet women in small groups or one-on-one in a neutral setting, like for coffee or with your children at a playground.

Offer to help them achieve their goals. Healthy women are often busy women, so spend time in their world and observe how they interact with others, how they handle their responsibilities. Volunteer to serve on a committee they run, or offer to work a few hours in their office.

Identify women who are a step or two ahead of you on the wellness trail, and be their encourager. You may find they will encourage you in return.

To Read: Ephesians 4:14-16

Am I My Brother's Keeper?

We will speak the truth in love, growing in every way more and more like Christ, who is the head of his body, the church.
EPHESIANS 4:15

HOW DO YOU SHOW RESPECT to parents, and how much should parents run your life? What is a person's responsibility toward a grown sibling? Should you lend him or her money? Help them with constant marriage problems?

One woman shared how her parents thought she and her husband needed to buy her siblings new cars just because they had purchased a new car. Another had a sibling who thought her childless sister was obligated to pay for her three nieces to go to private school. Another sister was always at her house. Are you wondering how you can show love and respect and still maintain healthy boundaries?

Perhaps the most loving thing we can do is to give a loved one responsibility for his or her own life. I try to ask myself, *If love wants the best for another person, then what would love do?*

One mother, who realized her constant bailing out of her grown son was actually crippling his growth into maturity, wrapped up a note that read, "This is the best and most difficult gift I have ever given you. Enclosed you will find a check, the last one you will receive from me. This will cover your first and last month's rent and your bills for one month, but you also see that I have enclosed a set of apron strings. I am giving you the gift of being responsible for your own life, so I have cut the apron strings. Please enjoy this gift. All my love, Mom."

Real love makes the hard calls, does the brave thing, and encourages people to step up and step out. Love gives generously from a willing heart in a way that encourages responsible maturity. Sometimes the most treasured gift is the most difficult to give and impossible to wrap.

To Read: 2 Thessalonians 1:3-12

Pulling Up Short

*All this is evidence that God's judgment is right, and
as a result you will be counted worthy of the kingdom
of God, for which you are suffering. God is just: He
will pay back trouble to those who trouble you and
give relief to you who are troubled, and to us as well.
This will happen when the Lord Jesus is revealed from
heaven in blazing fire with his powerful angels.*

2 THESSALONIANS 1:5-7, NIV

PULLING UP SHORT, quitting, throwing in the towel, giving up, or walking away—we all want to do it much more than we are willing to admit. So what do you do when you've run out of steam but the train station of rest is at the top of the next mountain?

What did the apostle Paul do? He reminded himself and others of the following:

What we suffer now is nothing compared to the
glory he will reveal to us later. (Romans 8:18)
We don't look at the troubles we can see now;
rather, we fix our gaze on things that cannot
be seen. For the things we see now will soon
be gone, but the things we cannot see will last
forever. (2 Corinthians 4:18)

I once thought these things were valuable, but now I consider them worthless because of what Christ has done. Yes, everything else is worthless when compared with the infinite value of knowing Christ Jesus my Lord. For his sake I have discarded everything else, counting it all as garbage, so that I could gain Christ. (Philippians 3:7-8)

Dear brothers and sisters, I have not achieved it, but I focus on this one thing: Forgetting the past and looking forward to what lies ahead, I press on to reach the end of the race and receive the heavenly prize for which God, through Christ Jesus, is calling us. (Philippians 3:13-14)

Paul didn't look at the task, at the work, or at the suffering. He looked beyond, farther down the trail to the finish line. Are you tired? Do you feel like throwing in the towel? Change your gaze.

To Read: Psalm 18:25-36

A Fake

In your strength I can crush an army;
with my God I can scale any wall.

PSALM 18:29

AMANDA IS A SMART COOKIE! She graduated eighth in her class, yet for years she felt like a fake. She graduated from college with honors, and landed her first job in a male-dominated field, but she was full of fear:

"It is not like you can just go up to a coworker or boss and say, 'You hired me to be an expert, but every time I make any decision, I second-guess myself. My paperwork all says I have the brains for this job, but I feel like such a fake. I am so afraid every time I have to make a decision or give an answer.'

"One night, driving home, I heard a speaker on Christian radio talk about women and self-esteem and how many women believe lies about themselves and are full of self-doubt. Then she said, 'They feel like a fake.' I couldn't believe it—that was exactly how I felt! How did she know? As I listened, I learned many women feel this

way. I wasn't alone, but I was buying into Satan's sham. And with God's help, I could fight this battle!"

To battle negative thoughts, replace them with positive ones about God and his view of you. I like to paraphrase verses and string them together, like:

I have no fear of sudden disaster or of the ruin that overtakes the wicked, for the Lord will be my confidence and will keep my foot from being snared.[1] In him and through faith in him I may approach God with freedom and confidence.[2] Being confident of this, that he who began a good work in me will carry it on to completion until the day of Christ Jesus.[3] I will approach the throne of grace with confidence, so that I may receive mercy and find grace to help me in my time of need.[4] This is the confidence I have in approaching God: that if I ask anything according to his will, he hears me. And if I know that he hears me—whatever I ask—I know that I have what I asked of him.[5] I am convinced of better things . . . things that have to do with salvation.[6]

To Read: Luke 10:25-37

Lack in Love

*"Love the Lord your God with all your heart and with
all your soul and with all your strength and with all
your mind"; and, "Love your neighbor as yourself."*
LUKE 10:27, NIV

A COLLEAGUE WAS TALKING about discipling and training
leaders. "When I see that a person has a deficit in his or
her relationships with people, I know they have a deficit in their relationship with God. When we are rightly
relating to God, we gain the ability to rightly relate to
others. The key is to discover what is missing in their
relationship with God."

What's missing in your relationships with people?
Are you . . .

Short with people? Maybe you are angry at God
about his provision or timing.

Noncommunicative? How much are you praying
and talking with God?

Distant? Maybe you have a hurt you haven't allowed
God to heal.

Keep running away from commitments? How are you doing keeping your commitments to God?

Hiding in drugs, shopping, or booze? What are you hiding from God? Pain? Disappointment? Trauma?

Always nagging? How's your trust level with God? Feeling like you need to help him out?

Resentful? Your underground anger will go deeper unless you let God meet the need you feel the person near you is supposed to meet.

Look at your relationships—is there an unhealthy pattern? Now transpose that to your relationship with God. Invest in your primary relationship (with God), and you may see improvement in all your secondary ones (with people).

To Read: Exodus 20:2-18

All about You!

You must not have any other god but me.

EXODUS 20:3

SATAN WANTS YOUR EYES OFF GOD. To get you distracted, he doesn't move your eyes to himself; rather, he subtly moves them to *you*. He twists the truth so that you are now the object of worship. To illustrate the point, let's see what would happen if we rewrote the first six of the Ten Commandments so that instead of God being the focus, you were:

1. You are the lord of your own life. Don't let anyone else tell you what to do!
2. Create your own religion. Use whatever god you want if you think it will get you ahead.
3. Have as many idols as you want. Follow sports teams and movie stars, spend time and money on cars, drugs, music, sex—whatever you want. It's your life, your money, and your call.

4. Swear whenever you want. In fact, say anything you want, whenever you want. Don't let social mores, your parents, church, or anything else keep you from expressing yourself any way you want to.
5. Don't get hung up on going to church—it's just a building. Besides, they are just a bunch of hypocrites anyway. Be "spiritual" any way you like!
6. Don't listen to your parents. Those old people will just hold you down. Family is like a noose around your neck. If you feel like being with your family, fine, but don't feel obligated. No guilt trips!

Have any of those thoughts crossed your mind? It's amazing how when you actually say those things, you can see how self-centered and evil they sound. God wants you to honor him by obeying his Word. It's not all about you but rather all about him—the Lord your God.

To Read: John 8:31-47

Twisting

*[The devil] was a murderer from the beginning,
not holding to the truth, for there is no truth in
him. When he lies, he speaks his native language,
for he is a liar and the father of lies.*

JOHN 8:44, NIV

SATAN IS A DECEIVER. Let's continue rewriting the last of the Ten Commandments and notice how he wants to feed your lust and your desires, while leaving out the consequences. Satan might say:

"Murder might be a gift. Death isn't really so bad. Death is a great escape, suicide a statement." The Bible says Satan comes to steal, kill, and destroy. Satan doesn't tell someone in a rage, bent on self-mutilation, self-destruction, or suicide, "Wait, consider the consequences." No, he wants you to go with the emotion of the moment.

"Have sex with whomever you want. If it feels good, do it! Marriage is overrated—look, hardly anyone is happily married. Fulfill all your desires, right now, any way you want." The Bible says that marriage is the best place for sex because it is a committed relationship. Trust is

the key to sexual fulfillment, and trust is built by commitment. Satan wants you to use others and to be used. He wants you to get hooked on sex, not hooked on love, because love reflects God.

"Take what you want. If someone is stupid enough to leave it right there in open sight, they are just asking for you to take it. You need it more than they do." I don't think Satan brings up jail sentences while tempting.

"White lies are all right. Say whatever you need to cover for yourself. If you want it, go after it: someone's house, car, boyfriend, husband, clothes, or status. Take them down. Your needs are most important." Satan won't mention to you that a certain statement or action could destroy a friendship or work relationship. He wants to put you on the hook, not take you off the hook. He wants to leave you twisting in the wind.

To Read: Judges 4:4-16

A Skirt on a Platform of Suits

Then Deborah said to Barak, "Get ready! This is the day the LORD will give you victory over Sisera, for the LORD is marching ahead of you." So Barak led his 10,000 warriors down the slopes of Mount Tabor into battle.

JUDGES 4:14

HITTING THE GLASS CEILING? Feeling outnumbered by the guys? Feel like the good old boys' club is giving everyone else the edge? As women, sometimes we can feel out of the loop or passed over, and Judge Deborah could have felt that way too. She is the only woman judge included in the Bible.

But God had obviously called her, for people would travel long distances just to have her judge their cases. Her wisdom and fairness were known throughout the kingdom. Even Barak wouldn't go into battle without her:

> She sent for Barak son of Abinoam from Kedesh in Naphtali and said to him, "The LORD, the God of Israel, commands you: 'Go, take with you ten thousand men of Naphtali and Zebulun and lead them up to Mount Tabor. I will lead

Sisera, the commander of Jabin's army, with his chariots and his troops to the Kishon River and give him into your hands.'"

Barak said to her, "If you go with me, I will go; but if you don't go with me, I won't go."

"Certainly I will go with you," said Deborah. "But because of the course you are taking, the honor will not be yours, for the LORD will deliver Sisera into the hands of a woman." So Deborah went with Barak to Kedesh.

JUDGES 4:6-9, NIV

And that is exactly what happened: Jael lured the king in for a bite to eat and a nap, then "nailed" him with a tent peg through the temple. God gave the opportunity and the credit to a woman.

As you seek what God has for you to do, stay focused on his wisdom and encouragement.

Know that God hasn't forgotten you because of your gender—keep being yourself, and like Deborah and Jael, your moment will come.

To Read: Psalm 119:59-64

Adrift

I pondered the direction of my life, and
I turned to follow your laws.
PSALM 119:59

"WE JUST DRIFTED APART." This is the most common excuse a person gives when she wants out of a marriage. It is the foundation for no-fault divorce and the legal term *irreconcilable differences.* Most differences can be reconciled, and usually it is a "*both*-fault" divorce. There is no drifting apart; rather, it is a series of decisions, choices, and attitudes that distance two people. Just as it is choices that made you "drift," choices can also move your hearts back toward each other.

If you are feeling stressed in a relationship, retrace your steps, just as you would if you lost your car keys. Love, like lost keys, can be found.

Review your history: When do you last remember being happy, emotionally connected, and in love? What was going on in both of your lives then? What changed: a

job? an attitude? a circumstance? a set of responsibilities? Try to specifically discern what changes occurred.

Once, Bill and I found we were growing impatient with each other. Everything we did seemed to irritate the other. Yes, we were carrying a heavy load of responsibility, but that was characteristic of our entire married life. What was different?

As I retraced my steps, I observed that we had always carried a full plate of responsibility, but we had carried much of it together. Our current ministry and work responsibilities had us functioning independently too often. So we made choices and decisions to cause change. We moved our offices next to each other, scheduled in ministry we could do together, and delegated ministry responsibilities that would keep us apart. Just as choices moved us apart, choices brought us together.

To Read: Psalm 26:2-3

Does a Pattern Emerge?

Put me on trial, LORD, and cross-examine
me. Test my motives and my heart.

PSALM 26:2

"WHAT'S UP? All my relationships are exploding on me!" Sharon had been married twice; her children, now in college, made excuses for never calling, never coming home. She was passed over for a promotion at work, and now her fiancé was getting cold feet—he wanted to postpone the wedding.

"He told me I am high maintenance! What does that mean? Am I, Pam? Am I high maintenance?"

Telling a high-maintenance woman she is high maintenance likely will trigger an explosive response and may or may not lead to change. However, change is more likely if a high-maintenance woman with emotional issues realizes it herself.

"Why don't you look at all your relationships? Go back and write down what you think happened to strain the relationship. Better yet, go ask them why

the relationship is strained. You need to be like a court reporter or journalist. Take notes on what they say; don't react—no matter what they say. Set up some interviews, and see if you can gather enough information to see a pattern."

"What do I ask? I don't think I can do this! It's too hard!"

"Harder than losing all the people you love, over and over again?"

"Well, when you put it like that—okay—can you help me? What do I say to them?"

"Just ask each of those people to go to coffee with you. I'll give you a few questions to ask, but it's more important that they hear your heart. They need to hear that you are sorry your relationship is strained and that you want to see if you can change or do something to rebuild the relationship. Your most important job will be to listen and not react."

To Read: Hebrews 11:1-40

Living by Faith

Now faith is confidence in what we hope for
and assurance about what we do not see.
HEBREWS 11:1, NIV

AT A CONFERENCE for pastors' wives, I heard Jill Briscoe recount a painful circumstance in her family life when she prayed frantically, asking and demanding of God. She caught herself and said, "I am praying like a woman who has no faith." Then she began to praise God for what she knew to be true about him instead of praying her feelings.

She said, "I asked myself, How would I live if all my prayer requests were answered?" Prior to this she had felt anxious, frustrated, discouraged—but after she decided to live as if all her prayer requests were answered, she found new peace and hope.

That is really the essence of faith. Faith can be defined as the persuasion or moral conviction of the truthfulness of God or a religious concept, especially reliance upon Christ for salvation.

Taking the definition apart, faith is living fully persuaded of God's abilities and character. Faith is a conviction, a full commitment to the truth and living out what you know intellectually. Faith is relying consistently on God because you believe.

How are you living? Are you shouting at God? Are you angry at his plan? at his timetable? What prayer requests are dominating your days and keeping you up at night?

Write out how you would live if God answered them all. Would you be less preoccupied? Would you be able to "be in the moment" rather than always planning and fretting? Would you have a longer fuse? Would you treat people differently? Write it out—then live it out!

Live as if God has answered—that's what a walk of faith is all about!

To Read: James 1:5-8

Ask Me!

If you need wisdom, ask our generous God, and he will give it to you. He will not rebuke you for asking.

JAMES 1:5

WOMEN ARE FULL OF GREAT IDEAS, but so few of us really ask God to make the ideas happen. God commands us to come to him for advice, direction, and wisdom.

Ask. He knows you want it. "For your Father knows what you need before you ask him" (Matthew 6:8, NIV).

Ask in agreement with another. "I tell you that if two of you on earth agree about anything they ask for, it will be done for them by my Father in heaven" (Matthew 18:19, NIV).

Ask, especially if it will bring glory to God. "I will do whatever you ask in my name, so that the Father may be glorified in the Son" (John 14:13, NIV).

Ask, and remain in God's Word for the answer. "If you remain in me and my words remain in you, ask whatever you wish, and it will be done for you" (John 15:7, NIV).

Ask with right motives. "You desire but do not have, so you kill. You covet but you cannot get what you want, so you quarrel and fight. You do not have because you do not ask God. When you ask, you do not receive, because you ask with wrong motives, that you may spend what you get on your pleasures" (James 4:2-3, NIV).

Ask if it's in God's will; he will answer. "This is the confidence we have in approaching God: that if we ask anything according to his will, he hears us. And if we know that he hears us—whatever we ask—we know that we have what we asked of him" (1 John 5:14-15, NIV).

All he can say is no; then you're in the same spot as you are now. But God may say yes! Our vulnerability in asking will only strengthen and grow our relationship with him. Just ask!

To Read: Psalm 108:1-5

Fully Rely on God!

Your unfailing love is higher than the heavens.
Your faithfulness reaches to the clouds.

PSALM 108:4

I HAVE A BRIGHT GREEN TOY FROG sitting on my bed. My friend Kendyl gave it to me when I was going through a really tough place emotionally. Around this frog's neck is an acrostic from a talk given by Daisy Hepburn:

Fully
Rely
On
God

Those toy frogs have been the perfect encouragement for many of my friends and me to remember to fully rely on God in hard times: when a spouse leaves, a child is in crisis, a friend disappoints us, a teen rebels, a home burns down, or other trials. There are many reasons why we women need to fully rely on God. And there are many

ways to do that. I once gave my friends bracelets shaped like a set of mountains with a note that I would pray for them in the ups and downs of life. Having a friend pray over you can be very powerful. It helps to study the attributes of God or get an audio Bible and play it day and night. Write a letter to Jesus, completely surrendering to him and asking him to take over the situation. Sing a favorite hymn or praise chorus until you actually believe it. And spend time praying these verses:

> Turn your ear to listen to me; rescue me quickly. Be my rock of protection, a fortress where I will be safe. You are my rock and my fortress. For the honor of your name, lead me out of this danger.
>
> PSALM 31:2-3

To Read: Psalm 28:6-8

Choosing Joy

The LORD is my strength and shield. I trust him with
all my heart. He helps me, and my heart is filled
with joy. I burst out in songs of thanksgiving.

PSALM 28:7

IN ONE PARTICULARLY STRESSFUL season of life, when we
were going through a very public difficulty but most of
the details were either too complicated or too personal
to share, people would ask me, "How are you doing?"

I would answer, "I am choosing joy!" Most of us have
only a few friends we trust enough and feel safe sharing
intense emotion. So that response seems to protect both
the person asking and the person answering. The best
part of answering, "I am choosing joy!" is that it helps
you do just that.

A quick scan of the Hebrew and Greek words trans-
lated "joy" shows that when you choose joy, you are
choosing exceeding gladness, pleasure, rejoicing, cheer-
fulness, and calm delight. Those are definitely the things
I want from life! So how do you choose joy? Choose
Jesus instead of the emotion at hand. Make a conscious

choice to worship instead of worry. Here are some great statements about what Jesus will do for you when you choose the joy he gives:

- You have turned my mourning into joyful dancing. You have taken away my clothes of mourning and clothed me with joy. (Psalm 30:11)
- When doubts filled my mind, your comfort gave me renewed hope and cheer. (Psalm 94:19)
- I pray that God, the source of hope, will fill you completely with joy and peace because you trust in him. Then you will overflow with confident hope through the power of the Holy Spirit. (Romans 15:13)

The next time you're experiencing a time of stress, choose joy!

To Read: Psalm 143:8-12

Do It by Ones

*Teach me to do your will, for you are my God; may
your good Spirit lead me on level ground.*

PSALM 143:10, NIV

IN THE GAME OF CRICKET you can move ahead, then win
the game in small increments, or "ones."

While traveling and preaching in a foreign country
that was challenging and dangerous, Jill Briscoe felt
overwhelmed by the task at hand. Her husband, Stuart,
said, "Do it by ones."

Elisabeth Elliot, whose husband, Jim, was killed by
a tribe she later went back to minister to, was asked,
"How do I know God's will?" Elisabeth responded, "Do
the next thing."

My husband, Bill, believes that it is in the small,
daily, even mundane decisions of life that we gain
ground for God.

Often we want victory to be won once and for
all! We want a dramatic rescue or an exciting event to
change our lives. However, we gain ground and move

from chaos to change in small steps. Galatians 5:25 says, "If we live in the Spirit, let us also walk in the Spirit" (NKJV).

The word *step* means "to march or keep step," like in the military. Think about marching—it isn't dancing; it is just one foot in front of the other, over and over and over again.

Victory comes if we "do the next thing," if we "do it by ones," and if we live one day at a time. Level ground is the goal. When we can get out of the drama and chaos and onto level ground, we can go full speed ahead. If we have lofty goals, they will be attained if we can daily do the next thing. It is like we are biking up the mountain and soon we'll be on the flatland, where we can make great gains and distance ourselves from past failures. One day at a time—"Do it by ones!"

To Read: Exodus 34:29-35

Facing God

Whenever [Moses] went into the Tent of Meeting
to speak with the LORD . . . the people of Israel
would see the radiant glow of his face.

EXODUS 34:34-35

THE LORD SPOKE TO MOSES face-to-face, just like a
friend (Exodus 33:11). Moses had a real, deep friend-
ship with God. What were the results of his friendship
with God?

Moses overcame insecurities. When God first called
him, Moses felt insecure. "Pardon your servant, Lord, I
have never been eloquent, neither in the past nor since
you have spoken to your servant. I am slow of speech
and tongue" (Exodus 4:10, NIV).

But the Lord encouraged him by saying that he
would help him speak and teach him what to say. God
walked Moses through numerous scenarios that might
happen with Pharaoh and told him how to respond.

Moses reorganized his strengths to accomplish God's
plan. God helped Moses see he was the man for the job,
since Moses knew the language, beliefs, and customs

from growing up in the palace. God gave him the insight to see how to use all these skills, talents, and experiences for God's people.

Moses gained faith to lead, then delegate. He gained supernatural strength from his meetings with God, like when he was given the Ten Commandments for the people. Only a strong leader can lay out rules—people are resistant to rules. Then Moses was able to take good advice from his elders, appointing representatives to share leadership. Only a secure leader can share position and power.

Meeting with God regularly prepared Moses for the next step. What's your next step? Don't know? Get away with God. Know the next step but feel afraid? Get away with God. To face it, face him.

To Read: Romans 6:15-23

Failure

*I am using an example from everyday life
because of your human limitations.*
ROMANS 6:19, NIV

WE HATE THE WORD *FAILURE*, don't we? The thought of having to say it aloud sends shivers up the spine, ties our stomach in knots, and gives us a headache! However, if we never say we are wrong, then we can never figure out what would be right! There is no sin in saying we have failed.

If you are not matching up to the Bible and God's plan in one area of your life, it is not news to God. He already sees it! "Everyone has sinned; we all fall short of God's glorious standard" (Romans 3:23). Left to yourself, using all your own strength and power, you will fall short. Paraphrased, it might be, "You were wrong. You failed. You are not perfect." It is no sin to acknowledge you fell short—that is just agreeing with God. God likes it when you live in agreement with him.

However, there is a sin if you say, "I am a failure."

Jesus came down and died in our place so we'd never have to see ourselves as a failure. Instead of replaying Satan's lies in your mind, reject the lie and state the truth.

"The truth is I have failed here. The truth is that God sees me as a winner, so what do I need to change to get my reality to match up with God's picture of me?"

Is there a sin to avoid, a habit to unlearn, a new skill to learn, or a piece of information I need? If I did this all over again, what would I do differently this time?

To Read: 2 Kings 4:19-37

Get the Best

Elisha summoned Gehazi. "Call the child's mother!"
he said. And when she came in, Elisha said, "Here,
take your son!" She fell at his feet and bowed before
him, overwhelmed with gratitude. Then she took her
son in her arms and carried him downstairs.

2 KINGS 4:36-37

THE BIBLE TELLS A STORY of a rich woman who built the prophet Elisha a room in her home. One day her only son grabbed his head in pain and collapsed. The woman held her son on her lap as he died. For a parent, this is a crisis of great proportion. There was nothing this woman could do to help her son. The problem was far beyond her own limited power or ability. What did she do? She promptly went to someone who could help her:

> When she came to the man of God at the
> mountain, she fell to the ground before him
> and caught hold of his feet. Gehazi began to
> push her away, but the man of God said, "Leave
> her alone. She is deeply troubled." . . .
> Elisha returned with her. . . .

He went in alone and shut the door behind him and prayed to the LORD. Then he lay down on the child's body, placing his mouth on the child's mouth, his eyes on the child's eyes, and his hands on the child's hands. And as he stretched out on him, the child's body began to grow warm again! Elisha got up, walked back and forth across the room once, and then stretched himself out again on the child. This time the boy sneezed seven times and opened his eyes!

2 KINGS 4:27, 30, 33-35

This woman in need went after the best help she could think of. She needed someone who had the *ability* and the *desire* to help her. We can learn an important lesson from this woman's example. When we face a crisis, we can go to the One with the greatest ability to help and the greatest desire. Our heavenly Father's heart wants his children to cry out for his help when their path takes them through difficulties. We can find no better help and no more loving heart than his. When you're in a tight spot, look for help with a heart.

To Read: Psalm 107:39-43

How Could Anything Possibly Go Wrong?

*Those who are wise will take all this to heart; they will
see in our history the faithful love of the LORD.*

PSALM 107:43

EVE WAS CREATED by a perfect God and placed in a perfect environment, and Adam sure seemed like a perfect husband. After all, when he first laid eyes on Eve, he broke into spontaneous praise of his new wife. And he had a great job: tend a perfect Garden. They didn't call it Paradise for nothing! So how could anything possibly go wrong?

A small thing: Eve wasn't perfect! She wanted more out of the Garden. Waking up every day next to a handsome man wasn't good enough. (I am assuming Adam was handsome, because God was the creator and the Fall had not happened.) And living in a perfect setting wasn't good enough (it hadn't even rained yet!). No, Eve wanted more; she wanted to have God's ability, God's power to know good from evil.

Now this is a lofty goal—wanting to know what God

knows—and a finite being can never know what an infinite one does. Eve wasn't designed to be God; she was designed to be Adam's helpmate. But she didn't take her job very seriously—she got Adam into trouble right off the bat!

What can we learn from Eve? Here are a few principles I have gleaned from her:

- Self-improvement is a good goal *if* I do it God's way, in his time, and according to his principles.
- Listening carefully and obeying can save me a lot of trouble. Eve added to God's rule not to eat the fruit; she told the serpent she couldn't touch it! It's easy to get an attitude about rules that don't make sense to us—Eve's addition may have made her vulnerable to the serpent's persuasive words.
- Be careful to whom you listen. Why was she talking to a snake when she had God to talk to? She hadn't even been in the Garden long enough to get bored with Adam's company.

To Read: Galatians 6:7-10

I Give Up!

Let's not get tired of doing what is good. At just the right
time we will reap a harvest of blessing if we don't give up.
GALATIANS 6:9

I HAVE FELT IT, and I have heard it:

"Why bother? It's just going to fail anyway."

"Why call? They won't come."

"Why try? It's like beating my head against a brick wall."

"This wasn't worth the work."

"All this effort—for this outcome?"

"I give up."

Giving up is easy. Giving in takes no effort. There is pain in the struggle, especially in the struggle to live a holy and healthy life. There is work, hard work, involved in taking back darkness.

Our youth pastor calls himself a "hell rescuer," based upon Colossians 1:13: "He has rescued us from the kingdom of darkness and transferred us into the Kingdom of his dear Son."

Have you ever looked at a police officer after a shoot-out? a firefighter after he has carried someone out of a burning building? a search-and-rescue leader after she has rappelled down a cliff to save a stranded and injured person? a lifeguard after he has saved someone from drowning in the ocean? They look tired! Rescuing is hard work!

Being God's instrument in his work of rescuing others takes tireless prayer and an intense drive to "be there"—inviting, reminding, giving healthy options, and training. It is work.

Exhausting? Yes!

Rewarding? Yes!

Necessary? Definitely!

To Read: Psalm 90:14-17

Make the Most of Morning

Satisfy us each morning with your unfailing love,
so we may sing for joy to the end of our lives.

PSALM 90:14

THE ANNOYING ALARM, the quick stop at Starbucks for coffee, a bit of breakfast—if you are lucky! Is this your morning ritual? Want to trade it in for a new routine?

Here is some inspiration: "Abraham got up early that morning and hurried out to the place where he had stood in the LORD's presence" (Genesis 19:27). "Listen to my voice in the morning, LORD. Each morning I bring my requests to you and wait expectantly" (Psalm 5:3). "As for me, I will sing about your power. Each morning I will sing with joy about your unfailing love" (Psalm 59:16).

Wouldn't you rather start your day this way? If you currently aren't spending time with God in the morning, try to give him five minutes before anything else gets in the way:

Pray through your day before you get out of bed, and ask for his help.

Rise to the sound of Christian radio rather than the buzz of an alarm.

Read a psalm a day or a proverb a day. Write down a phrase to post on your mirror or desk, and meditate on it all day.

Read a devotional such as *Daily Light on the Daily Path*.

Record your prayers in a journal.

What are the results? A heart that rejoices and sings throughout the day.

To Read: 1 Samuel 2:1-10

Need a Breakthrough?

Hannah prayed: "My heart rejoices in the LORD! The
LORD has made me strong. Now I have an answer for
my enemies; I rejoice because you rescued me."

1 SAMUEL 2:1

HANNAH WAS A WOMAN who needed a breakthrough. First Samuel 1:15 has Hannah explaining, "I am a woman who is deeply troubled" (NIV). Other Bible translations say she was oppressed in spirit.

Did she stay troubled and oppressed? What did she do to get out of her trouble and oppression? She looked up, and she poured out.

Look up: She went to the Temple, where she knew she could talk to God openly and honestly.

Pour out: Hannah tells Eli, "I was pouring out my soul to the LORD" (NIV). She was so free with her feelings that when the priest, Eli, saw her, he thought she was drunk. She had no inhibitions as she expressed her pain and sorrow.

Where do you go when you need to hold court with God? When I am experiencing incredible sorrow, pain,

or overwhelming responsibility, I look for a place to talk, cry, pace, and maybe even rant and rave a bit to God.

This honesty gained a breakthrough for Hannah. She made a commitment to God and then kept that commitment. From her barrenness of womb and emptiness of soul, she came to a level place where she had the strength to give her beloved only son to God for full-time ministry.

She went from weakness to strength, and it started with an honest heart-to-heart with God.

To Read: 1 Kings 17:1-7

Stop!

Elijah did as the LORD told him and
camped beside Kerith Brook.

1 KINGS 17:5

FOR YEARS, YOU'VE SEEN commercials of a little pink battery-operated bunny beating a drum who . . . "keeps going, and going. . . ."

Many of us think we are that bunny, driven to keep going, going, and going. While hard work is admirable, and diligence is necessary, so is stopping. Even race-car drivers in the lead have to take a pit stop and have their crew change tires and refuel.

My favorite example from the Bible is Elijah, the prophet who had to constantly battle evil kings who were in leadership in Israel: "The LORD said to Elijah, 'Go to the east and hide by Kerith Brook, near where it enters the Jordan River. Drink from the brook and eat what the ravens bring you, for I have commanded them to bring you food.' So Elijah did as the LORD told him and camped beside Kerith Brook, east of the Jordan.

The ravens brought him bread and meat each morning and evening, and he drank from the brook" (1 Kings 17:2-6).

God told him to stop, so he stopped. He completely unplugged. The ravens' feeding him is a precursor to our room service. He pulled away from all people and stopped all activity. The only things he could do in this isolated spot were eat, drink, rest, and worship. (He might have done a few stretches, but there's no record of any aerobic activity!)

Take out your yearly calendar, and mark off rest periods with stop signs. Look for times of fast pace, demanding deadlines, or significant life changes (like a child being married or leaving for college), and place a stop sign—a break—after those activities or transitions.

Like the wise race-car driver who strategically plans pit stops, you, too, might find yourself in the winner's circle.

To Read: Luke 22:39-46

Pray to Win

"Why are you sleeping?" [Jesus] asked them. "Get up
and pray, so that you will not give in to temptation."
LUKE 22:46

WHAT DOES GOD THINK important enough to pray for?
What are the areas God sees as vital for success in life?
We get a glimpse from the scriptural prayer requests
below.

Pray:

For your enemies and those who persecute or
 mistreat you (Matthew 5:44; Luke 6:28).
For strength to not fall into temptation
 (Matthew 26:41).
For reconnected relationships (Romans 1:10-11).
You are rescued from unbelievers (Romans 15:31).
You won't make mistakes (2 Corinthians 13:7).
Your heart will be enlightened to understand
 the wonderful future he has promised
 (Ephesians 1:18).

You will be strengthened by the Holy Spirit
(Ephesians 3:16).

You will be rooted and established in love
(Ephesians 3:17).

You will open your mouth and be given words
to fearlessly and clearly share the gospel
(Ephesians 6:19; Colossians 4:4).

God will count you worthy of your calling and
fulfill every good purpose of yours prompted
by your faith (2 Thessalonians 1:11).

You will be generous because of your faith and have
a full understanding of all the good things you
can do for Jesus (Philemon 1:6).

You will have a clear conscience (Hebrews 13:18).

If you have trouble or sickness (James 5:13-14).

To confess sin (James 5:16).

For good health (3 John 1:2).

To Read: Romans 11:25-36

Red Marks the Spot

God's gifts and his call can never be withdrawn.
ROMANS 11:29

RAHAB BELIEVED the Hebrew spies. She learned about the true God from them. She believed enough to let them down to escape through her window on the wall. Now it was time to act on her belief. The instructions were clear.

She and her family had to be in the house, and the red cord must hang from the window. No matter what was happening around them, she must believe and then act on this information (see Joshua 2:17-18). The troops of Israel marched around her city.

For seven days she wouldn't let her family leave. Some may have complained, some may have doubted her, but she stood firm. They had to stay and wait there. The red cord was their safety line to freedom.

God has called you to freedom. He has laid a dream on your heart. You have a calling—are you going to act

on it? Some people may criticize you, others may doubt, and some may complain.

Will you still stand firm in your call and act on it? Doing so will lead to freedom.

To Read: Mark 6:30-44

Run Away

Jesus said, "Let's go off by ourselves to a quiet
place and rest awhile." He said this because there
were so many people coming and going that Jesus
and his apostles didn't even have time to eat.

MARK 6:31

A GROUP OF MOTHERS CHATTED: "I was so upset and
stressed the other night, I felt like running away from
home!"

"I hear you! Once, I was so mad at my husband I
wanted to run away. It was late at night, so I couldn't fig-
ure out where to run. I didn't want to spend the money
for a hotel or drive to one myself at that hour. The beach
isn't safe, so I just went and sat in the car! Then I was
afraid even sitting in the car alone. I thought, *This is
stupid! Why do I want to run away? Everyone I love is in
that house!* So I went back in and went to sleep. Things
looked better in the morning."

"I know. One time I was so stressed, so frustrated
with my family, I wanted to go on strike and leave them
on their own. Then I thought, *They will think I am crazy
if I up and leave at 2 a.m.* So I stayed, and over breakfast

I said, 'I want everyone to know that I am going to spend today and tonight at a health spa. I need a day off, and you'll be on your own for meals.'

"Their response, including my husband's was, 'That's great, Mom! You deserve it!' I couldn't even be mad at them anymore, but I did go to the spa anyway. It was great!"

Maybe you need a break, instead of an emotional breakdown.

Plan some time that will restore and replenish you.

To Read: Psalm 75:1-10

Say Thanks

We thank you, O God! We give thanks because you are
near. People everywhere tell of your wonderful deeds.

PSALM 75:1

HOW CAN YOU THANK GOD? He is so good, holy, and awesome. He needs nothing, not even our thanks, but he longs to hear us give thanks.

Notice how Hannah gave thanks:

"Hannah prayed: 'My heart rejoices in the LORD! The LORD has made me strong. Now I have an answer for my enemies; I rejoice because you rescued me'" (1 Samuel 2:1).

She expresses her delight. "No one is holy like the LORD! There is no one besides you; there is no Rock like our God" (verse 2).

She acknowledges God's character. "Stop acting so proud and haughty! Don't speak with such arrogance! For the LORD is a God who knows what you have done; he will judge your actions" (verse 3).

She gives a warning. "The LORD gives both death

and life; he brings some down to the grave but raises others up. The LORD makes some poor and others rich; he brings some down and lifts others up" (verses 6-7).

She exalts God for his power. "For all the earth is the LORD's, and he has set the world in order. He will protect his faithful ones, but the wicked will disappear in darkness. No one will succeed by strength alone. Those who fight against the LORD will be shattered. He thunders against them from heaven; the LORD judges throughout the earth. He gives power to his king; he increases the strength of his anointed one" (verses 8-10).

Make your own list of why you delight in God and what you have seen him do for you. Observation and remembrance are great forms of thanks.

To Read: Isaiah 48:12-19

The Flight

This is what the LORD says—your Redeemer,
the Holy One of Israel: "I am the LORD your
God, who teaches you what is good for you and
leads you along the paths you should follow."

ISAIAH 48:17

I WAS ON AN AIRPLANE I wasn't supposed to be on. My flight had been canceled the night before, and I was given a hotel room and a flight out the next day. I wanted to sleep in a bit since we got to our room at 1 a.m., so I took a 10:30 a.m. flight.

Because so many people from the canceled flight I was to be on were rerouted to an early morning flight, Terri, a mom flying standby, discovered her first flight option was 10:30, too. As we sat next to each other, I learned she was going to a Christian college to see if she could iron out a housing glitch for her son. He was supposed to have a dorm room but had just received notice he did not.

I also had a son moving out to attend college, so my heart went out to her. I offered to pray for her and her son. I asked her to let me know how God answered. I

knew in my heart that God would provide something; her son wanted to grow in his walk with God.

A few weeks later I got an email thanking me for my calming prayers and relaying the good news: Her son had a dorm room!

Every day, there are people along our path whom God has called us to encourage. As we do so, we see miracles, and God builds our faith. We see how God puts two women, neither of whom was "supposed" to be on a flight, in seats next to each other and gives encouragement and hope in Christ.

God moves people to places for their good and for his glory.

To Read: Psalm 69:13-17

The Heart of Creativity

Answer my prayers, O LORD, for your unfailing
love is wonderful. Take care of me, for your mercy
is so plentiful. Don't hide from your servant;
answer me quickly, for I am in deep trouble!

PSALM 69:16-17

DESPERATION IS OFTEN at the heart of creativity. Moses' mom was desperate. The pharaoh, afraid the people of Israel were growing too strong in number, was commanding all baby boys to be killed at birth.

She'd do anything to save her son. Where could she hide a baby? What if he cried? What if someone came by the house?

You can almost imagine her scouring the house, looking frantically for an answer and praying. Then she eyes a basket! She might have thought, *It looks the right size, but the baby's cries could still be heard in the house. The river! If I could just hide the baby in the reeds, far from human ears.*

But how could she make sure the basket stayed afloat? Tar and pitch! So she coated the basket, placed the baby inside, and asked her daughter to stand guard.

God sparked her creativity, and a whole nation was saved by that baby, who grew into the nation's leader and deliverer.

Are you feeling stuck? Do you need a new idea or to be rescued in some situation?

Pray! Then look around—the answer may be sitting right in front of you.

To Read: Revelation 17:3-14

This Is Hard Work!

Together they will go to war against the Lamb, but
the Lamb will defeat them because he is Lord of
all lords and King of all kings. And his called and
chosen and faithful ones will be with him.

REVELATION 17:14

THERE ARE TIMES when doing God's will seems like it's too much, too hard, too impossible. John must have heard a few complaints, and believers under his leadership had real issues: The government was against them, taking businesses, separating families, and even killing Christians. It had to have been tempting to pull up short. But John goes beyond a pep talk. He doesn't guilt them into obedience. Rather, John explains *how* to obey: "This is love for God: to keep his commands. And his commands are not burdensome, for everyone born of God overcomes the world. This is the victory that has overcome the world, even our faith. Who is it that overcomes the world? Only the one who believes that Jesus is the Son of God" (1 John 5:3-5, NIV).

John acknowledges that obedience seems like a burden, then goes on to explain the key to victory: faith

in Jesus. Earlier in the same letter, he reminds them of the power that lies just beneath the surface of their own skin: First John 4:4 explains, "You, dear children, are from God and have overcome them, because the one who is in you is greater than the one who is in the world" (NIV).

Jesus in them. The Christ who rose from the grave gives his resurrection power to all of us who believe. He won at the Cross, and he can win anytime we give him the cross he has asked us to bear. We can be confident in our victory because Jesus is victor. His very essence is victory till the end.

"God, I can't, but through your power, I can!"

To Read: Philippians 3:7-11

Under the Surface

I no longer count on my own righteousness through
obeying the law; rather, I become righteous
through faith in Christ. For God's way of making
us right with himself depends on faith.

PHILIPPIANS 3:9

A PROSTITUTE. She was used to the looks, the catcalls. She was even used to the feeling of being used by men. But she was not used to the kindness and the respect she was given one day by some men whom she knew were spies for the people of God.

She had heard much about the strength of their God. He seemed bigger, more real than the gods of stone and wood that sat carved about her city.

She told the men how she and her people reacted to their God and all he had done. But she also asked them to swear to show kindness to her and her family because of the kindness she showed them. Asking for a sign, she was told by the men that it would be their lives for hers, and they promised they would treat her kindly and faithfully when God gave them the land (Joshua 2:11-14).

Smart woman—she could spot a good deal! All she'd seen were bad deals her whole life. So when she saw the opposite, she knew it had to be the *real* deal.

How about you? The best deal ever offered was Jesus' righteousness for your imperfection. Have you claimed your right to this deal?

You won't get a better offer.

To Read: Colossians 2:1-5

Unity

*I want them to be encouraged and knit together
by strong ties of love. I want them to have
complete confidence that they understand God's
mysterious plan, which is Christ himself.*

COLOSSIANS 2:2

MORE CAN BE ACCOMPLISHED together than separately.
There's a synergy that happens when individuals join
their skills, talents, and resources together, focused on a
single purpose. Goals are accomplished.

But achieving unity and keeping it is no easy task:
"Again I say, don't get involved in foolish, ignorant argu-
ments that only start fights. A servant of the Lord must
not quarrel but must be kind to everyone, be able to
teach, and be patient with difficult people" (2 Timothy
2:23-24).

If God's Word acknowledges the challenges of work-
ing together, we realize how much we have to depend on
God to achieve the unity he calls us to. "What is causing
the quarrels and fights among you? Don't they come
from the evil desires at war within you? You want what
you don't have, so you scheme and kill to get it. You are

jealous of what others have, but you can't get it, so you fight and wage war to take it away from them. Yet you don't have what you want because you don't ask God for it" (James 4:1-2).

So what should we ask God for when we desire unity? According to James in the verses we just read, we should pray that we don't give in to the natural desire to react badly if we don't get what we want.

Then there are some key elements that create unity:

- Choosing a bond of peace (Ephesians 4:3)
- Choosing to love above everything else (Colossians 3:14)
- Choosing to keep Christ as the primary focus (Philippians 2:21)

To Read: Philippians 4:19-23

What Do You Need?

This same God who takes care of me will supply all your needs from his glorious riches, which have been given to us in Christ Jesus.

PHILIPPIANS 4:19

IF YOU WALK CHILDREN through a toy store, you will hear their mantra: "But, Mom, I neeeeed that!"

What exactly is a need? In my quiet time journal, I was trying to sort out the differences between a want and a need. I looked up *need* in the dictionary and learned that a need is a condition requiring supply or relief.[1]

I had to agree with God that most of the time when I told God I neeeeeded something, I was a lot like a child in a toy store. I just *thought* I needed it. Now I ask myself: Is this a requirement? Is it pressing? Is it urgent? Is it a means of basic sustenance?

In the book of Acts, the church rallied to supply each other's needs: "They sold their property and possessions and shared the money with those in need" (Acts 2:45).

So then I asked myself, What would I sell if someone I loved needed food? needed shelter? I had to be

honest—most everything would go! I really don't have that many "needs"!

God says he will supply my needs, and he goes beyond that. He meets needs according to his riches, and he owns it all!

To Read: Jeremiah 20:7-9

The Biggest Fear

If I say I'll never mention the LORD or speak in his name,
his word burns in my heart like a fire. It's like a fire in my
bones! I am worn out trying to hold it in! I can't do it!
JEREMIAH 20:9

THE NUMBER ONE FEAR of the majority of people is speaking in public. But speaking up seems to be one fear God wants us all to get over. So where do we begin?

Speak out about what breaks your heart. "I cannot keep from speaking. I must express my anguish. My bitter soul must complain." (Job 7:11)

Speak about what you know best, and wait to see what bridge God will provide to speak of himself. "I speak with all sincerity; I speak the truth." (Job 33:3)

Speak about God's love. "I have not kept the good news of your justice hidden in my heart; I have talked about your faithfulness and saving power. I have told everyone in the

great assembly of your unfailing love and
faithfulness." (Psalm 40:10)

Speak to give the reasons for your faith. "To whom
can I give warning? Who will listen when I
speak?" (Jeremiah 6:10)

*Speak what God tells you, and leave the response and
results to God.* "When I give you a message,
I will loosen your tongue and let you speak.
Then you will say to them, 'This is what the
Sovereign LORD says!' Those who choose to
listen will listen, but those who refuse will
refuse, for they are rebels." (Ezekiel 3:27)

Speak and tell what you've seen God do. "I assure
you, we tell you what we know and have seen,
and yet you won't believe our testimony." (John
3:11)

Speak the truth. "I speak with utter truthfulness.
My conscience and the Holy Spirit confirm it."
(Romans 9:1)

Speak of victories God has given. "I will not venture
to speak of anything except what Christ has
accomplished through me." (Romans 15:18, NIV)

DAY 55

To Read: Mark 10:13-16

The Heart of a Child

*I tell you the truth, anyone who doesn't receive the
Kingdom of God like a child will never enter it.*

MARK 10:15

TRY APPROACHING GOD like a child if you want to keep
your relationship fresh and to grow quickly. Lie on your
bed in the dark and talk openly and honestly to him
about your life. *Now I lay me down to sleep, I pray the
Lord my soul to keep. . . .* Then talk to him about how
you'd like him to keep your heart and soul.

A few years ago my Sunday evening children's pro-
gram had many new believers and five pastors' kids. One
evening I had the children all lie down on the floor.
I dimmed the lights, and I asked the pastors' kids to
pray like they do at bedtime. What a refreshing sound!
The simple yet great theology of those little children
was inspiring. I left that night realizing that I often let
the hectic pace of responsibility steal away those simple,
peaceful moments.

I made a vow that day to try to recapture some quiet

margin in my life. I linger a little longer with the Lord after my husband has started snoozing, I savor the warmth of hot tea, and I pray as I wait and read my Bible in the morning. I walk. I simply walk around the block and talk with God about my life when things get harried in my office or at my house.

Have a quiet time with a child, and ask the child to teach you and explain to you what they think a verse means. Children have a fresh view of God. A mother was teaching her three-year-old daughter the Lord's Prayer. For several evenings at bedtime she repeated it after her mother.

One night she said she was ready to solo. The mother listened with pride as she carefully enunciated each word right up to the end. "And lead us not into temptation," she prayed, "but deliver us some email. Amen."

To Read: Romans 12:1-3

A Turtle of Change

Don't copy the behavior and customs of this world, but
let God transform you into a new person by changing
the way you think. Then you will learn to know God's
will for you, which is good and pleasing and perfect.

ROMANS 12:2

A WOMAN WAS WALKING along the beach when she saw a huge sea turtle stranded on the sand. She ran to get the ranger, who jumped into his Jeep, drove to the turtle, and hooked one end of a chain around the turtle and the other end to the bumper. Then he gunned the motor and dragged the reptile over the sand. At the edge of the water, the ranger stopped, removed the chain, and heaved the turtle out into the water. She hit the surface with a *splat*; then she shook her head as if she were dazed and dove under the water. As she surfaced, she shook her head once again, swam a few strokes, and then ducked under the waves. She was finally home where she belonged.

Isn't that the way many of us feel when we face change? As we're pulled into new situations and challenges, we're not sure whether the change is going to kill us or be part

of God's care for us. Change is uncomfortable—even painful—and we may not be willing to change until the pain of staying where we are (stuck in the sand) becomes greater than the pain it will take to change (the pain of hitting the water).

We may wonder about a woman who stays with a physically abusive spouse year after year, thinking he will eventually change. We may ask why people stay in a job they hate instead of seeking something better. We struggle to understand why some people keep smoking, drinking, or eating the wrong foods long after the doctor has warned them of the health danger. Romans 12:2 tells us not to stay where we are, where the rest of the world is. Instead, we're to be transformed; that is, changed.

Like the turtle, we, too, may feel dazed when we find ourselves in a new environment. But if we keep on swimming, we'll arrive at the place God designed for us. Are you willing to be transformed? Ask God to bring you to the new place he has prepared.

To Read: Joel 2:12-17

Take a Break

Announce a time of fasting; call the people
together for a solemn meeting.
JOEL 2:15

FASTING IS CONSIDERED a spiritual discipline. It provides a time to focus on God so he can focus your life. It is a choice to yield your life to God's voice by making a space for him.

"Blessed is the one who does this—the person who holds it fast, who keeps the Sabbath without desecrating it, and keeps their hands from doing any evil" (Isaiah 56:2, NIV).

It isn't just food that can rob our time and our hearts from God. Today's world provides ample opportunity for distractions. Try a unique fast like skipping your favorite TV program, and have a quiet time instead, or take a mental health day and skip the housework and laundry or your normal work routine. Or skip the chocolate, cola, or coffee that seems to have a habitual hold on you.

You might fast from your talk radio or music station in the car as you drive and pray instead. Because I value the discipline that I gain from a fast, I routinely ask myself a few times a year, *Is anything tugging my heart away from God? Is there some action or habit that has taken residence in my life that has a strong command of my time, talent, and thought life?*

Anytime you break the routine and give God the time, he is faithful to meet you there. Which would you like to try: a fast from food, an activity, or a habit?

Use a quiet time this week to try something that will give you a change of discipline.

To Read: James 1:21-27

It's What's Inside
That Counts

*Pure and genuine religion in the sight of God the
Father means caring for orphans and widows in their
distress and refusing to let the world corrupt you.*

JAMES 1:27

THERE'S A SECTION OF SCRIPTURE that is like being
thrown into an ice-cold lake on a windy day—it gets
your attention. It is so easy to fall into "spiritual" auto-
pilot. Here are some signs from the book of Isaiah:

> Day after day they seek me out; they seem eager
> to know my ways, as if they were a nation that
> does what is right and has not forsaken the
> commands of its God. They ask me for just
> decisions and seem eager for God to come near
> them. "Why have we fasted," they say, "and
> you have not seen it? Why have we humbled
> ourselves, and you have not noticed?"
>
> Yet on the day of your fasting, you do as you
> please and exploit all your workers. Your fasting
> ends in quarreling and strife, and in striking

each other with wicked fists. You cannot fast as you do today and expect your voice to be heard on high. . . . Is that what you call a fast, a day acceptable to the LORD?

ISAIAH 58:2-5, NIV

Then God goes on to describe what "real" spirituality looks like: "Is not this the kind of fasting I have chosen: to loose the chains of injustice and untie the cords of the yoke, to set the oppressed free and break every yoke? Is it not to share your food with the hungry and to provide the poor wanderer with shelter—when you see the naked, to clothe them, and not to turn away from your own flesh and blood?" (verses 6-7, NIV).

Then God shares the impact "real" spirituality will have on your own life: "Your light will break forth like the dawn, and your healing will quickly appear; then your righteousness will go before you, and the glory of the LORD will be your rear guard. Then you will call, and the LORD will answer" (verses 8-9, NIV).

Are you "real"?

To Read: Psalm 98:1-9

Splurge

Let the rivers clap their hands in glee! Let
the hills sing out their songs of joy.

PSALM 98:8

SOMETIMES I FEEL LIKE SPLURGING on my relationship
with God. I escape to a friend's garden, or I bring out
the best china and have hand-dipped chocolates or
fresh homemade scones with specialty teas as I sit and
take in precious gems from God's Word. Or we curl up
together, I in a window seat cushioned with pillows, and
God enthroned on high.

Since my relationship with God is vital to all the rest
of my life, I don't like to shortchange my special times
with him. I regularly look for an extra day to spend in
solitude at a cozy mountain cabin, prayer in an art gal-
lery, or reading devotional books poolside.

Although always on a budget, I have looked for ways
to make my time with God special, out of the ordinary.
At times I want my relationship with God to be white
linen, crystal, rose petals, and lace. If I have to trim in

other areas to splurge with God, I will—that relationship deserves the best.

Find a garden, take your favorite journal, drawing pad, paints, or handwork. Sit quietly and take in just a tiny glimpse of what could have been before Eve ate the forbidden fruit. Try to express back to God your thanks that even though sin entered the world in the Garden, God redeemed humanity.

God is the creator, and since you are made in his image, try some creativity in his presence: Try to create a wonderful poem, photograph, painting, or cross-stitch.

To Read: Ephesians 1:3-14

Going Back to Move Forward

He is so rich in kindness and grace that
he purchased our freedom with the blood
of his Son and forgave our sins.

EPHESIANS 1:7

AS I LOOK BACK ON MY LIFE, I can see where the roots of perfectionism were planted. Once when I brought home my seventh-grade report card, it included six 100 percent grades and one 99.9 percent. My dad had been drinking, so "Jack Daniels" said through my dad, "Pam, why isn't that a 100 percent?" I remember wondering if I would ever be good enough to earn his love.

When I was eight, almost nine, the pastor of our small church asked if anyone in my Sunday school class wanted to learn more about Jesus. In the class we learned much about who Jesus was, and we also had an opportunity to gain a place on a quiz team. Now, because I always wanted to achieve, I wanted a place on that team! I could just see myself, like a contestant on *Hollywood Squares*, up on that podium, answering those questions.

But to gain a spot on the team, I had to memorize Matthew 5, 6, and 7.

While reading Matthew, I came across the verse "Everyone who asks, receives. Everyone who seeks, finds. And to everyone who knocks, the door will be opened" (Matthew 7:8).

I thought, *Does this mean that if I ask you to come into my life, Jesus, that you'll do it?* And there, sitting on my bed, I bowed my head and prayed, asking Jesus to come into my life to be my Savior, Lord, and best friend. I believe he met me there that day.

I felt free and loved unconditionally for the first time in my life. The next day was Sunday, and as was tradition, my pastor gave anyone who wanted an opportunity to come forward for prayer. I was crying. I remember my pastor asking me, "What's wrong, Pam?" I answered him, "I am so happy!"

That was the first day I remember crying tears of joy. Up until meeting Christ, my tears had been caused by feelings of failure; now, they were feelings of freedom.

To Read: Proverbs 24:23-27

Get Real

An honest answer is like a kiss of friendship.
PROVERBS 24:26

IT'S HARD TO BE REAL. We would much prefer that our success be rehearsed, scripted, and airbrushed. I want my sons to say just the right thing when introduced to important people, and I'd love to always sound profound and quotable. No one really likes to look or feel stupid. I wish every day was a good hair day and that I could keep the wisdom I had at forty but have the body I had at twenty. *Get real!*

I force myself to be real. I do open the front door when the doorbell rings even if the boys have just walked out with friends and forgotten to pick up the fast-food bags off the living-room table. I go to the grocery store *without* makeup, knowing full well that I might see people I know. I admit mistakes, flaws, foibles, and fears. Why?

It's exhausting to try to be perfect! It's too much

work to always wonder what everyone's thinking about me. I love what Patsy Clairmont says: "We'd worry less about what people thought of us if we realized how very little they do!"

In the Old Testament one of the definitions for *honest* is "straightforward." I love that picture because it means I am not going out of my way to present myself as something I am not.

Living straightforwardly saves time, energy, and worry. Once, while working on a writing deadline, I walked out of my home office and into a living room that was a wreck. It was summer, and the guys had everything they owned out! I thought, *What would my readers think if they saw my house right now?* Then I thought, *They'd think I was a real mom with a real deadline and a real life—get over it, Pam!*

To Read: Luke 15:1-7

All Different?
All the Same?

Tax collectors and other notorious sinners
often came to listen to Jesus teach.
LUKE 15:1

LOOK AROUND YOUR WORLD. Does everyone look like you? Does everyone not only carry the party line but also hold it? Are you surrounded by yes-men and women? Is everyone in a similar tax bracket? Are your social circles the same year after year? Are all your friends your age and stage of life? There is a danger in this.

Variety in relationships will safeguard your success. Diversity in dialogue will protect your ability to think clearly. Looking at an issue or idea from all angles protects your future.

Of course, your closest friends will likely carry similar backgrounds and beliefs, but it is wise and biblical to expand your relationship circle.

Jesus didn't just hang out with the priests. They weren't his buddies, and their hypocrisy made him angry, but he still engaged them in conversation.

In heaven all types of people will be there. Revelation 5:9 describes the scene: "You are worthy to take the scroll and break its seals and open it. For you were slaughtered, and your blood has ransomed people for God from every tribe and language and people and nation."

Yes, it benefits us to hang out with those who are different from us. Having a single woman edit my women's books helps me reach a broader audience. Having friends of all races keeps me sensitive to their faith needs or traditions. Having friends in all denominations makes me think through my theology. Having friends of all ages and stages helps better prepare me for life's journey as well as keeps me relevant to a changing culture.

Do you need to make a few more new and unique friends?

To Read: 2 Corinthians 9:1-8

Promises, Promises

You must each decide in your heart how much to give.
And don't give reluctantly or in response to pressure.
For God loves a person who gives cheerfully.

2 CORINTHIANS 9:7

ONE MAN COMMITTED TO GOD to give a certain percentage of his income for as long as he lived. From his first week's pay he gave one dollar to the Lord. Soon his weekly offering had increased to ten dollars. As time went on, he continued to prosper. Before long he was giving a hundred dollars a week, then two hundred, and in time, five hundred dollars a week.

This process started out as an intense joy because this man felt his hard work was making life better for many people. But after a while he found himself in conflict. He began to think this was his money and that he shouldn't be giving away so much. Finally he called a close friend.

"Remember the promise I made to God years ago?" he said. "How can I get released? When I made the promise, I only had to give a dollar, but now it's five

hundred dollars. I can't afford to give away money like that."

His wise friend said, "I'm afraid you cannot get a release from the promise, but there is something we can do. We can kneel down and ask God to shrink your income so that you can afford to give a dollar again."

God deserves the best. First Chronicles 16:29 explains: "Give to the LORD the glory he deserves! Bring your offering and come into his presence. Worship the LORD in all his holy splendor."

Has God blessed you? Have you asked God how he might use you to bless others?

"Lord, you gave me everything. All of what I have is really yours. How do you want me to best use it?"

To Read: 2 Corinthians 3:1-6

The Letter

The only letter of recommendation we need is you
yourselves. Your lives are a letter written in our
hearts; everyone can read it and recognize our good
work among you. Clearly, you are a letter from
Christ showing the result of our ministry among
you. This "letter" is written not with pen and ink,
but with the Spirit of the living God. It is carved
not on tablets of stone, but on human hearts.
2 CORINTHIANS 3:2-3

THE APOSTLE PAUL explains how God has written a letter on our hearts in 2 Corinthians 3:2-3. Because of what God has done in our lives, others can read his work in our lives through the Holy Spirit. *We are a letter.*

The phrase *written on our hearts* means a past act that has ongoing results. When we decide to surrender our lives to Christ, the Holy Spirit indwells us, sealing us to God (Ephesians 4:30, NIV). And the Holy Spirit writes a letter on each of our hearts in permanent, nonerasable ink.

However, even though the letter may have been written in the past (and for many of us who have known Christ for twenty to thirty years, it is a distant past!), this verse explains that our letter is still contemporary, usable, and "with it" because the verbs *known* and *read* are in present tense, which means continual action.[1]

You have been chosen to carry the message of hope. From the moment you received Christ, you became one of his "greeting cards," bringing good news.

God "cares enough to send the very best." Where is he "mailing you" today?

To Read: 1 Corinthians 1:26-31

Go to Court!

God has united you with Christ Jesus. For
our benefit God made him to be wisdom itself.
Christ made us right with God; he made us
pure and holy, and he freed us from sin.

1 CORINTHIANS 1:30

HOW DOES LIFE TRANSFORMATION take place? Romans
3:24 says that we are "justified freely by his grace" (NIV).

Justification is a legal term. It is a picture of all our
sins being logged into a portfolio or file. (And each of
us has a thick file of imperfections, mistakes, and sins!
Think of it as your permanent record or, as those in
law enforcement call it, your jacket.) Then God sent his
Son, Jesus, down to earth to live a sinless life. He had a
file folder full of perfect credits; he is righteous. Then on
the cross, God took our sins from our file and switched
them with Jesus' righteousness. Jesus paid the penalty
for our file folders, for our jackets of imperfection! God
now looks down on us from heaven and sees Christ's
righteousness where our sins once were.

Justification is a onetime act that happens when we
meet Christ. Having justified us, God begins a process

of sanctification. Second Corinthians 3:17-18 tells us: "The Lord is the Spirit, and wherever the Spirit of the Lord is, there is freedom. So all of us who have had that veil removed can see and reflect the glory of the Lord. And the Lord—who is the Spirit—makes us more and more like him as we are changed into his glorious image."

Jesus is in the process of moving us from the weakness that characterized our lives before conversion toward a position of strength as seen from heaven.[1] It is like going to court to get the legal process moving. When you come to Christ and tell him you want his righteousness for your sin, he makes the trade for your "jacket."

Have you made the trade?

To Read: Proverbs 8:1-10

Real Freedom

Choose my instruction rather than silver,
and knowledge rather than pure gold.
PROVERBS 8:10

DURING MY QUIET TIMES, I studied the "you are's" that God says about us. I was encouraged by the positive ones, like you are strong, chosen, children of the promise, and standing firm.

But for me personally, the ones that were most freeing first appeared negative. Some of these, I didn't even like. I wished they weren't even there! For example, 1 Corinthians 3:2-3 explains, "You are still not ready. You are still worldly" (NIV). Romans 6:19 points out that we have "human limitations" (NIV). Hebrews 5:11 mentions that we "no longer try to understand" (NIV).

I came to realize that freedom isn't the same as denial. I am slow to learn, weak, and still worldly, and if I ever think I have arrived, I will be lying to myself. These things are just as true about me and you as all the other more positive things God says about who we are.

God has done us a favor when he tells us in Matthew 15:19, "From the heart come evil thoughts, murder, adultery... slander." It is to our advantage to know that we have a selfish bent wanting our way over God's way.

And every time we give in to our selfishness, we prove that "no one is righteous—not even one. No one is truly wise; no one is seeking God. All have turned away; all have become useless. No one does good, not a single one" (Romans 3:10-12).

God knows that we don't always have it all together. But it is also clear that as we embrace our imperfections and acknowledge we are weak, we gain the ability to become strong. Paul said: "When I am weak, then I am strong" (2 Corinthians 12:10).

First Corinthians seems to say, we have a choice.[1] Choose well today.

Dealing with Doubt

I will delight in your decrees
and not forget your word.
PSALM 119:16

AT TIMES, PEOPLE WONDER why a woman would spend so much time reading the Bible and praying. Maybe in a crunch you have told yourself, "I'm too busy to have a quiet time. Why pray? I need to just work harder and not spend my valuable minutes praying." Perhaps you have forgotten just why so much of the Christian life centers on time in the Word:

> The word of the LORD is right and true; he is
> faithful in all he does (Psalm 33:4, NIV). *Do you*
> *want to be faithful in all you do?*
> How can a young person stay on the path
> of purity? By living according to your
> word (119:9, NIV). *Do you want a pure life?*
> I have hidden your word in my heart that I might

not sin against you (verse 11, NIV). *Do you want to keep from sin?*

My soul is weary with sorrow; strengthen me according to your word (verse 28, NIV). *Do you need strength for the journey?*

Turn my eyes away from worthless things; preserve my life according to your word (verse 37, NIV). *Do you need help staying focused on the positive?*

Your word is a lamp for my feet, a light on my path (verse 105, NIV). *Do you need guidance?*

You are my refuge and my shield; I have put my hope in your word (verse 114, NIV). *Do you need shelter from a storm?*

Direct my footsteps according to your word; let no sin rule over me (verse 133, NIV). *Do you want to be in control of your life instead of life controlling you?*

These are just a few of the benefits of reading the Word. I don't have the time *not* to be in the Word!

To Read: 2 Corinthians 13:11-13

It's Pretty Simple, Really!

Greet each other with a sacred kiss.

2 CORINTHIANS 13:12

RELATIONSHIPS CAN FEEL so complicated, but really, God created a pretty simple set of relationship principles. If a relationship is feeling complicated, try these simple "one anothers," and see if the relationship improves:

John 13:34-35 (NIV): A new command I give you: *Love one another.*

Romans 12:10 (NIV): *Be devoted to one another* in love. Honor one another above yourselves.

Romans 12:16 (NIV): *Live in harmony with one another.* Do not be proud, but be willing to associate with people of low position. Do not be conceited.

Romans 14:13 (NIV): *Let us stop passing judgment on one another.*

Romans 15:7 (NIV): *Accept one another.*

Galatians 5:13 (NIV): *Serve one another* humbly in love.

Ephesians 4:32 (NIV): *Be kind and compassionate to one another, forgiving each other,* just as in Christ God forgave you.

Ephesians 5:21(NIV): *Submit to one another* out of reverence for Christ.

Colossians 3:13 (NIV): *Bear with each other* and *forgive one another* if any of you has a grievance against someone. Forgive as the Lord forgave you.

Colossians 3:16 (NIV): *Admonish one another* with all wisdom.

1 Thessalonians 5:11 (NIV): *Encourage one another* and *build each other up*, just as in fact you are doing.

Hebrews 10:24 (NIV): Let us consider how we may *spur one another on toward love and good deeds.*

James 4:11 (NIV): Brothers and sisters, *do not slander one another.*

1 Peter 4:9 (NIV): *Offer hospitality to one another.*

If you practice these principles and the relationship is still difficult, then at least you know it is probably an issue with the other person, not you!

To Read: Romans 12:12-18

Always Enough Time

Be joyful in hope, patient in affliction, faithful in prayer.
ROMANS 12:12, NIV

TAKE CARE OF THE NEEDY. Visit the widow. Evangelize the lost. Teach your children and grandchildren to love the Lord. Serve in the church. Serve in the community. Sometimes our to-do list can feel so long. It is easy to be driven by guilt or by need instead of being driven by God.

But look at Romans 12:12. It's all about attitude: Be joyful, patient, faithful. The context helps too. Romans 12:1 says that each one of us is to be a "living sacrifice" (NIV). Romans 12:2 says, "Do not conform to the pattern of this world, but be transformed by the renewing of your mind" (NIV). These are attitude adjustments. Romans 12:3: "Do not think of yourself more highly than you ought, but rather think of yourself with sober judgment, in accordance with the faith God has distributed to each of you" (NIV). *Attitude.* Then Romans

12:4-8 encourages people to be who they are and use the gifts God has given them. No unreal expectations, no harsh criticism, just let people be who God made them. *Attitude again.* God is concerned with your attitude behind your actions. Get off the frantic, guilt-driven merry-go-round. Focus less on what you are "doing" and more on who you are "being."

To Read: 1 Peter 3:13-18

The Least Popular

Even if you suffer for doing what is right,
God will reward you for it. So don't
worry or be afraid of their threats.

1 PETER 3:14

IT IS EASY TO PEDDLE A GOSPEL of "happy ever after," but in suffering we discern who we are and what we are made of:

Suffering connects our hearts to Christ's. "How is
it to your credit if you receive a beating for
doing wrong and endure it? But if you suffer
for doing good and you endure it, this is
commendable before God. To this you were
called, because Christ suffered for you, leaving
you an example, that you should follow in his
steps." (1 Peter 2:20-21, NIV)
Suffering purifies and forges our faith. "In all this you
greatly rejoice, though now for a little while you
may have had to suffer grief in all kinds of trials.
These have come so that the proven genuineness

of your faith—of greater worth than gold, which
perishes even though refined by fire—may result
in praise, glory and honor when Jesus Christ is
revealed." (1 Peter 1:6-7, NIV)

Suffering is used by God to put his glory on display.
"Dear friends, do not be surprised at the fiery
ordeal that has come on you to test you, as
though something strange were happening to
you. But rejoice inasmuch as you participate
in the sufferings of Christ, so that you may be
overjoyed when his glory is revealed. If you are
insulted because of the name of Christ, you are
blessed, for the Spirit of glory and of God rests
on you." (1 Peter 4:12-14, NIV)

*Suffering builds intimacy into our relationship with
God.* "Those who suffer he delivers in their
suffering; he speaks to them in their affliction."
(Job 36:15, NIV)

On those "bad days," think of the payoffs: a closer
God connection, a more pure faith, a life that puts
God on display, and a God who will speak to me in my
affliction.

To Read: John 11:38-44

What Will People Think?

*Jesus responded, "Didn't I tell you that you
would see God's glory if you believe?"*
JOHN 11:40

OVERALL, WE HAVE an exaggerated sense of self. We worry about what we will wear, serve, say, give, do, and contribute. We worry because our eyes are on ourselves.

I don't see Jesus calling up Peter and John and asking, "So, what are you going to wear to the wedding today?" I don't see him running around frantically worrying about what he is going to serve for dinner—and he had some big dinner parties. Remember when he fed five thousand men and their families from two fish and some bread?

He didn't even worry when it seemed he should have been worried, like when he was on a boat in the middle of a storm. He wasn't worried; he slept!

He wasn't even stressed about not being there when Lazarus, one of his best buddies, died. Everyone was stressed, but when Jesus arrived, he wanted to see the

tomb and asked them to remove the stone. Lazarus's sister Martha was concerned and stressed about what the smell would be like, since her brother had been in the tomb four days. But Jesus looked at her and said, "Didn't I tell you that you would see God's glory if you believe?" (John 11:40).

When we worry, all we see is the circumstance, and all others see in us is stress. But when we believe in God despite the circumstances, we see the glory of God.

What do you want to see today?

To Read: Ecclesiastes 3:11-15

I Don't Get It!

God has made everything beautiful for its own
time. He has planted eternity in the human heart,
but even so, people cannot see the whole scope
of God's work from beginning to end.

ECCLESIASTES 3:11

"I DON'T 'GET' GOD." I have heard that statement from teens, seniors, and everyone in between. There are times when we don't understand why God does what he does; we don't find the logic of his timing; and we don't comprehend some basic tenets of the faith, like the Trinity or free will and God's sovereignty. God is "ungetable."

What we need to get is, we can't "get God." If we could, then he wouldn't be God—he'd be like us. Isaiah 64:4 says that "since the world began, no ear has heard, and no eye has seen a God like you, who works for those who wait for him!" If since the beginning of time, no one else has seen a God who compares with him, how can we think we can?

If we could fully understand him, he wouldn't be God. Solomon, the wisest man who ever lived, acknowledged that he couldn't understand God either: "No one

can discover everything God is doing under the sun. Not even the wisest people discover everything, no matter what they claim" (Ecclesiastes 8:17).

He is bigger, stronger, wiser, and completely different from us. We need a God we can't get, because then he can give what we so desperately need.

To Read: Job 33:1-9

It's What's on the Inside

You said, "I am pure; I am without sin;
I am innocent; I have no guilt."

JOB 33:9

I KNOW I'VE SAID IT TO MY KIDS, and I remember my mother and my grandmother saying it to me. "It's what's on the inside that counts." Money, prestige, beauty are all fleeting; character, integrity, and honesty last. Crisis doesn't just build character—it reveals it.

I think that's why I appreciate David's prayer in Psalm 51. You see, he's just blown it. He tried to run a cover-up scam, and the prophet Nathan blew the whistle on him. David realized that it's what's on the inside that counts! David prayed for God to give him a clean heart and to renew his spirit (verse 10).

How can we keep this type of right standing with God?

Run away from sin; follow righteousness.
(2 Timothy 2:22)

Ask: Does this thought or action pursue peace, love, and righteousness?

Walk into God's presence and away from false beliefs. (Psalm 24:3-4)

Ask: Does this action or attitude reflect God's Word?

Walk in the same path as your godly parents and grandparents. (2 Timothy 3:14)

Ask: What would my God-fearing dad, my pure-hearted mom, or my spiritual mentor do in my situation?

And what are the benefits gained by a clean heart and clear conscience?

We will have quality friendships with people of influence. "One who loves a pure heart and who speaks with grace will have the king for a friend" (Proverbs 22:11, NIV).

And we will have a stronger life because we have no regrets and no hidden skeletons in the closet (Job 17:9).

To Read: 1 Chronicles 28:4-10

Motive

Solomon, my son, learn to know the God of your
ancestors intimately. Worship and serve him
with your whole heart and a willing mind. For
the LORD sees every heart and knows every plan
and thought. If you seek him, you will find him.
But if you forsake him, he will reject you.

1 CHRONICLES 28:9

WHEN YOU WATCH a courtroom drama, the district attorney is looking for one thing that will get a solid conviction: *motive.* Motive is the reason why someone does or doesn't do something.

You might have experienced a relationship with someone who has selfish motives; you leave the relationship feeling used. Or you might have been involved in a business or project with someone with ulterior motives, and you leave the relationship feeling betrayed or deceived.

On the flip side, you might have been in a group with people who had selfless motives, and you go away from that experience feeling amazed at the altruistic, kind, and sacrificial nature of people.

How do we know? How can we tell someone's motives? First Corinthians 4:5 gives us a caution to not

judge before the Lord comes. He is the One who will expose the motives of each person's heart.

David, too, gave this warning to his own son before Solomon became king in 1 Chronicles 28:9. We are to watch our own motives and pray that we will see people from God's perspective, because God says he will bring the motive to light. When God's spotlight gets to me, I just pray my motives are pure.

To Read: Proverbs 10:20-32

God's Hand of Blessing

The blessing of the LORD makes a person
rich, and he adds no sorrow with it.

PROVERBS 10:22

WHEN GOD PLACES HIS HAND on you and trusts you
with a calling, why does he do it? Is it to make you
happy? Or is it to make you and the world more holy?
I think the second leads to the first. As you give, God
gives back. See the Proverbs 31 woman's example.

She is an industrious woman, making money, but for
what? She underwrites her ministry and family expenses,
and then she gives to the needy: "Her hands are busy
spinning thread, her fingers twisting fiber. She extends
a helping hand to the poor and opens her arms to the
needy" (verses 19-20).

With her weaving equipment, she is creating fabric
for clothes and goods. And she doesn't just make enough
for her own family, but she also makes enough for the
poor and needy: "She has no fear of winter for her
household, for everyone has warm clothes. She makes

her own bedspreads. She dresses in fine linen and purple gowns" (verses 21-22).

Because she has planned well, her own family is clothed well, and she has enough to even make a bedspread! She has earned enough to clothe herself in fine linen, the color of royalty.

When you treat others as royalty, God sends you a blessing fit for a queen!

To Read: Hebrews 4:6-11

It's Time!

God set another time for entering his rest, and that
time is today. God announced this through David
much later in the words already quoted: "Today when
you hear his voice, don't harden your hearts."

HEBREWS 4:7

WHEN A PERSON IS READY to respond to God, she asks
questions and seeks out people who want to talk about
God and the deeper issues of life. God draws people to
himself for salvation.

It's important that you act when someone you know
is seeking God. Assume it is a "God moment" if the
person wants to stay after a meeting to talk about God
or if she asks you to go to lunch when she has rebuffed
prior invitations. Clear your schedule to help someone
enter the Kingdom. Most of us pray and pray for our
family and friends to respond to God, but when they
don't meet our time schedule, we feel inconvenienced.
We should feel trusted and chosen instead!

In the same way, when a person is being stirred
by God, he or she is excited, animated, or deeply
introspective—not bland or benign. When you are

sensing God wants you to pull away, study, pray, or listen, do it!

God has a "today" for salvation, a "today" for his leading. He appoints moments; they are not random. Hebrews 4:7 says, "That time is today."

The main point of this Scripture isn't just to mention that God has end-time moments set, but rather God has moments that require our response "now."

To wait is to callous your heart, making it harder for God to get your attention next time.

To Read: John 20:11-18

The Best of Friends

"Mary!" Jesus said. She turned to him and cried out,
"Rabboni!" (which is Hebrew for "Teacher").
JOHN 20:16

HOW DOES JESUS treat the women who love him?

After the Sabbath, at dawn on the first day of the
week, Mary Magdalene and the other Mary went
to look at the tomb.

There was a violent earthquake, for an angel
of the Lord came down from heaven and, going
to the tomb, rolled back the stone and sat on
it. His appearance was like lightning, and his
clothes were white as snow. The guards were so
afraid of him that they shook and became like
dead men.

MATTHEW 28:1-4, NIV

Jesus came down—to our level. He meets us where we are.

153

The angel said to the women, "Do not be afraid, for I know that you are looking for Jesus, who was crucified. He is not here; he has risen, just as he said. Come and see the place where he lay. Then go quickly and tell his disciples: 'He has risen from the dead and is going ahead of you into Galilee. There you will see him.' Now I have told you."

MATTHEW 28:5-7, NIV

Jesus rose—and he takes us up a level with him. Knowing Christ elevates our status as women. Christ has a plan to move us up.

So the women hurried away from the tomb, afraid yet filled with joy, and ran to tell his disciples. Suddenly Jesus met them. "Greetings," he said. They came to him, clasped his feet and worshiped him. Then Jesus said to them, "Do not be afraid. Go and tell my brothers to go to Galilee; there they will see me."

MATTHEW 28:8-10, NIV

Jesus entrusts women with ministry. Jesus thinks women have a valuable place in spreading the good news of hope and help found in Christ.

He is reaching you right where you are today, he is lifting you up to maximize your talent and heart to create in you a message. Who is he sending you to tell?

Comfort in Chaos

*You will restore me to even greater honor
and comfort me once again.*

PSALM 71:21

HAVE YOU EVER NOTICED that sometimes the very people you are supposed to be ministering to and blessing end up blessing you? I have a friend who discovered an unusual growth, and during the testing and biopsy process, he and his wife sent us the following verses:

Praise be to the God and Father of our Lord Jesus Christ, the Father of compassion and the God of all comfort, who comforts us in all our troubles, so that we can comfort those in any trouble with the comfort we ourselves receive from God. . . .

We were under great pressure, far beyond our ability to endure, so that we despaired of life itself. Indeed, we felt we had received the sentence of death. But this happened that we

might not rely on ourselves but on God, who raises the dead. He has delivered us from such a deadly peril, and he will deliver us again. On him we have set our hope that he will continue to deliver us, *as you help us by your prayers.* Then many will give thanks on our behalf for the gracious favor granted us in answer to the prayers of many.

2 CORINTHIANS 1:3-4, 8-11, NIV,
EMPHASIS ADDED

I had been depressed about some serious issues until I got that letter. The passage changed my perspective completely. I knew that I was on the prayer team for my friend because God encourages us to pray for one another, but the phrase *as you help us by your prayers* gave powerful new significance to the work of prayer. In addition, it gave a new slant on the issues I was struggling with. I was reminded that God doesn't waste our pain; instead, when we go through tough places, God brings purpose to our pain. My time in God's vise grip was preparing me for the role of comforter in a whole new set of circumstances.

When life is pressing in on you, look around for purpose, for the lesson, for the way God is training you to serve and encourage others.

To Read: Jeremiah 31:1-6

Whom Can You Trust?

Long ago the LORD said to Israel: "I have loved you, my people, with an everlasting love. With unfailing love I have drawn you to myself."

JEREMIAH 31:3

THERE'S A STATEMENT that a young woman makes in the Bible that floors me: " 'I will do whatever you say,' Ruth answered" (Ruth 3:5, NIV). She will do whatever Naomi says? *Whatever?* That is amazing trust. They have either a deeply forged relationship or a very dysfunctional, codependent one!

From the context of the book of Ruth, we can see that she isn't some emotionally needy woman. Rather, she is called "noble" (Ruth 3:11, NIV) and "better than seven sons" (Ruth 4:15, NIV), and her godly character is noted by everyone around her. So this statement of respect and trust comes from an amazingly trusting relationship. Ruth has come to believe Naomi *always* has her best interests in mind. That's why she can hear a plan and simply say, "That's good, let's go with it!"

Who has your best interests in mind?

"For I know the plans I have for you," declares the LORD, "plans to prosper you and not to harm you, plans to give you hope and a future." (Jeremiah 29:11, NIV)

The thief comes only in order to steal and kill and destroy. I came that they may have and enjoy life, and have it in abundance [to the full, till it overflows]. (John 10:10, AMP)

Greater love has no one than this: to lay down one's life for one's friends. (John 15:13, NIV)

To trust God in the next step, remember how he has already expressed his love for you. Make a list of all the times and ways God has been there for you, provided for you, and given you opportunity and blessing. Then, when you are wondering if you should trust a person with your future, check out the person's love level for you (and for the God who loves you).

To Read: 1 Peter 1:21-25

Nana

*Now that you have purified yourselves by
obeying the truth so that you have sincere love
. . . love one another deeply, from the heart.*
1 PETER 1:22, NIV

I LOVE BEING AROUND new grandmothers! They have all the joy of a new mother, but without the pain and recovery.

Here's a snapshot of one "Nana" in the Bible:

The women said to Naomi: "Praise be to the LORD, who this day has not left you without a guardian-redeemer. May he become famous throughout Israel! He will renew your life and sustain you in your old age. For your daughter-in-law, who loves you and who is better to you than seven sons, has given him birth."

Then Naomi took the child in her arms and cared for him. The women living there said, "Naomi has a son!" And they named him Obed.

RUTH 4:14-17, NIV

Naomi had a baby? No, Ruth did! But Naomi is just as thrilled as a new mom. She is "renewed," thanks to her beloved daughter-in-law.

How was that relationship between mother-in-law and daughter-in-law established and nurtured?

> *Spiritual talks:* Ruth and Naomi must have had some, because Ruth left the false belief system she was raised with, married a believer, and after her husband died, she followed Naomi home to the Promised Land.
>
> *Shared memories:* The two women traveled together, back to Israel and around town. They both lost someone they loved: Ruth's husband and Naomi's son.
>
> *Solved problems:* They were broke, but they came up with a way to earn a living and start a home. They teamed up to triumph.

Mothers and daughters: Build a bridge to your in-laws. You might need them—and you might even enjoy them!

DAY 81

To Read: 1 Timothy 3:1-16

Moving Others to Health

I am writing these things to you now, even though I
hope to be with you soon, so that if I am delayed, you
will know how people must conduct themselves in the
household of God. This is the church of the living God,
which is the pillar and foundation of the truth.

1 TIMOTHY 3:14-15

THE APOSTLE PAUL was a people mover extraordinaire. He knew how to motivate others.

Level the playing field. Paul shares his fears. Then he gives them an opportunity to fix all of the issues before he even arrives: "I am afraid that when I come I may not find you as I want you to be, and you may not find me as you want me to be. I fear that there may be discord, jealousy, fits of rage, selfish ambition, slander, gossip, arrogance and disorder. I am afraid that when I come again my God will humble me before you, and I will be grieved over many who have sinned earlier and have not repented of the impurity, sexual sin and debauchery in which they have indulged" (2 Corinthians 12:20-21, NIV).

How can you make people feel more comfortable around you? How can you word your requests clearly and compassionately?

Look at the options. Paul shares that there are different approaches to handling problems and getting to the root of the matter. By laying out the worst discipline option (rods), the other looks pretty good. "I will come to you very soon, if the Lord is willing, and then I will find out not only how these arrogant people are talking, but what power they have. For the kingdom of God is not a matter of talk but of power. What do you prefer? Shall I come to you with a rod of discipline, or shall I come in love and with a gentle spirit?" (1 Corinthians 4:19-21, NIV).

Paul didn't overreact; he acted to get a response that produced fruit.

To Read: Philippians 1:27-30

Bad News
Turned Good

You must live as citizens of heaven, conducting yourselves in a manner worthy of the Good News about Christ. Then, whether I come and see you again or only hear about you, I will know that you are standing together with one spirit and one purpose, fighting together for the faith, which is the Good News.

PHILIPPIANS 1:27

SOMETIMES WE GET A PHONE MESSAGE, an email, or a secondhand version of negative news or criticism. Immediately our heart sinks. It beats harder and faster. Our head begins to swim with thoughts like, *Oh no! What did I do? What if they are mad at me? What if I lose this relationship?* or *What if this is just the tip of the iceberg and it gets worse, like a lawsuit, or they leave the church?* The what-ifs can make us crazy!

So when you get a glimpse of bad news, how should you handle it?

- *Focus on God:* Immediately take the concern to God, and plant it in the center of God's loving care. He is in control. He knows all things. None of this is a surprise to him.

- *Focus on getting to the truth:* Get firsthand, accurate information. If possible, quickly return the call, or go to the person. Listen—really listen. Don't try to defend yourself; ask God to be your defense and shield as you seek to listen for the pain or the root of the problem. If you react too quickly or become defensive, you may never really get to the bottom of the issue.

- *Focus on the positive:* Thank the person. Sharing bad news is no easy task. Calm the person with statements that will help everyone involved see how this is an opportunity for God to work or for everyone involved to learn and grow. Ask for time to pray or process the news.

To Read: Song of Songs 2:10-17

Catch the Foxes

Catch all the foxes, those little foxes, before they ruin
the vineyard of love, for the grapevines are blossoming!
SONG OF SONGS 2:15

WHEN LITTLE THINGS PILE UP in a relationship, the weight of all those small things becomes a big thing! Then when the one last "straw" is added, it breaks the back of the relationship just like a camel that can't carry one more thing. The king in Song of Songs wants to make sure that doesn't happen.

The king's wife grew up in the country on a vineyard. And they had small rodents (more like rats than our foxes) that would burrow underground and eat the roots of the vines. Although everything initially seemed lush and green in the vineyard, because the plants had no root system, whole sections of the vineyard would turn brown and die.

The newlyweds didn't want this to happen to their relationship. We all have little foxes that can ruin relationships:

Holding on to negative attitudes
Using harsh or critical words
Taking others for granted
Not valuing the other person's time, talent,
 or treasure
Having unspoken or unrealistic expectations
Not dealing with your own past baggage
Never saying, "I'm sorry"

There are a myriad of small things that can pile up. Instead, if you feel hurt or offended, say to that person, "I value our relationship too much to let this come between us. I need to share how I feel."

Are there any piles of unresolved feelings in any of your relationships? Go catch those little foxes.

To Read: Ephesians 5:25-33

Getting Him on Your Team

Again I say, each man must love his wife as he loves
himself, and the wife must respect her husband.

EPHESIANS 5:33

IF YOU ARE MARRIED, having a supportive spouse is vital to your ongoing success. If you are going to overcome a habit or your past or step into the future God has designed for you, it is all easier if your spouse is on your team. What kinds of things win your spouse over?

Let's look at the model the Proverbs 31 woman left: "A wife of noble character who can find? She is worth far more than rubies. Her husband has full confidence in her and lacks nothing of value. She brings him good, not harm, all the days of her life. . . . Her husband is respected at the city gate, where he takes his seat among the elders of the land" (Proverbs 31:10-12, 23, NIV).

Her husband feels she is worth much more than rubies because:

- he has full confidence in her;
- he isn't lacking anything he needs;
- she brings him good, not harm;
- he is respected among the public leadership.

As you reach toward your stars, does your husband still feel like he puts stars in your eyes? Looks like the Proverbs 31 wife made sure her husband had all the basics covered—at least everything that mattered in the public eye.

What he needed was there when he needed it (clean socks and underwear, the kids' needs being met and doing well in school, etc.). This doesn't mean she handles every detail, but she has made sure there is a system in place to get the needs met. You can delegate some to your spouse and the kids, and you can hire some out; but somehow you need to make sure he has confidence in both your dream *and* the dreams you have together.

To Read: Proverbs 31:1-31

Action!

Her children stand and bless her. Her husband
praises her: "There are many virtuous and capable
women in the world, but you surpass them all!"
PROVERBS 31:28-29

PROVERBS 31:10 INTRODUCES a poem explaining a
woman of noble character.

I have italicized the verbs in the passage. Notice how
many there are:

> She *brings* him good, not harm, all the days of
> her life.
> She *selects* wool and flax and *works* with eager hands.
> She is like the merchant ships, *bringing* her food
> from afar.
> She *gets up* while it is still night; she *provides* food for
> her family and portions for her female servants.
> She *considers* a field and *buys* it; out of her earnings
> she *plants* a vineyard.
> She *sets* about her work vigorously; her arms are
> strong for her tasks.

She *sees* that her trading is profitable, and her lamp *does not go out* at night. . . .

She *holds* the distaff and *grasps* the spindle with her fingers.

She *opens* her arms to the poor and *extends* her hands to the needy. . . .

She *makes* coverings for her bed; she *is clothed* in fine linen and purple. . . .

She *makes* linen garments and *sells* them, and *supplies* the merchants with sashes.

She *is clothed* with strength and dignity; she *can laugh* at the days to come.

She *speaks* with wisdom, and faithful instruction is on her tongue.

She *watches* over the affairs of her household and *does not eat* the bread of idleness. (Proverbs 31:12-20, 22, 24-27, NIV)

Do you notice a common thread? She's in action! Proverbs 31:28-29 is the result, and you're sure to want to be honored and have your kids call you blessed. But remember how she got there—she had an action plan. She's performing multiple tasks at home, at work, and in the community and is combining those with the responsibilities of parenting and character building. It is biblical to make those to-do lists! Are you in neutral gear in one area of life (home, work, service, church, parenting, etc.)? Select the weak link, and write a goal that will move you into action to make progress in that area.

To Read: Proverbs 11:12-16

Grace

A gracious woman attains honor.
PROVERBS 11:16, NASB

YOU'LL GET FURTHER WITH GRACE. One compliment a woman loves to hear is, "What a gracious lady" or "She has so much grace." In ballet, grace means a flawless performance that is so beautiful that those in the audience hold their breath. In beauty pageants, grace might mean gliding across the floor or having a witty, articulate answer to a stumping question. But what is a woman of grace from God's point of view?

God's grace is the giving of unconditional love and unmerited favor. God's grace is also the ability to see us as we can be, not as we are. God always sees his children's potential.

What is grace? Romans 3:24 explains that we "are justified freely by his grace through the redemption that came by Christ Jesus" (NIV). We are justified, or rendered free. We are redeemed, or ransomed.

So when we model Christlikeness in our ability to love and in our ability to yield to God so the fruit of the Spirit is seen in us, we are gracious.

Grace is especially noticed when it is in the midst of people of chaos, character flaws, and crudeness. Are you rising above the sea of sinfulness around you? Are you holding out a lifeline of God's love by modeling love?

To Read: Proverbs 12:1-5

Better Than Houses
and Money!

*A worthy wife is a crown for her husband, but a
disgraceful woman is like cancer in his bones.*

PROVERBS 12:4

PROVERBS 19:14 SAYS, "Fathers can give their sons an
inheritance of houses and wealth, but only the LORD
can give an understanding wife." The NIV uses the word
prudent for *understanding*, and other Bible translations
use the word *wise* or *worthy*. If being wise or prudent
or worthy is better than inherited wealth of homes and
money, how does the Bible define this concept?

Proverbs 12:16: "A wise person stays calm when
insulted."
Proverbs 12:23: "The wise don't make a show of
their knowledge, but fools broadcast their
foolishness."
Proverbs 13:16: "The wise don't think before they
act."

Proverbs 14:8: "The prudent understand where they are going."

Proverbs 14:15: "The prudent carefully consider their steps."

Proverbs 22:3: "A prudent person foresees danger and takes precautions."

A common thread seems to run through these verses: The prudent person *thinks* it through.

Notice that prudence or wisdom isn't a feeling. How many of your decisions are made out of emotions? Do you buy something because the person selling it is sweet or is your cousin or you owe your aunt some favor? (The favor is now a guilt offering!) Do you spend when you feel depressed or eat treats because you feel entitled?

For a week, track how you make decisions, and see how much emotion might be influencing your thought process.

To Read: Titus 2:3-5

Workers at Home

*They can urge the younger women to love
their husbands and children, to be self-
controlled and pure, to be busy at home, to be
kind, and to be subject to their husbands, so
that no one will malign the word of God.*

TITUS 2:4-5, NIV

HOW CAN WE BALANCE work, home, family, marriage,
and ministry? Some people of faith try to balance a
woman's life by limiting her call to home and family,
often citing Titus 2:3-5.

What does "busy at home" mean? Word studies
define "worker at home" as "a guard of the home; a
keeper of the home; domestically inclined."

I studied this verse and that phrase in depth, I read
volumes of commentators and word study books, and in
the end, the best synopsis for "worker at home" is that
a woman's heart is home. Her priorities reflect a God-
and family-focused value system. So her feet could be
anywhere, but her heart is at home.

I have operated under this definition for all of my
children's lives, and it seems to be working. My husband
feels loved, my children are grown, and all are strong

spiritually. I have helped provide for my family, and some people have also been helped in ministry along the way.

Your feet can be anywhere, but is your heart at home?

To Read: 2 Corinthians 8:10-15

In Your Court

Now finish *the work, so that your eager
willingness to do it may be matched by your
completion of it, according to your means.*

2 CORINTHIANS 8:11, NIV (EMPHASIS ADDED)

TENNIS IS COMPELLING. A serve is volleyed, and there are
only two choices: Hit it back, or miss the opportunity
and lose control of the ball again. When the ball is in
your court, you have to keep control of the ball to win.

The ball is in your court, a phrase we toss about freely,
is a pretty strong challenge said in a nice way. It means,
"I pass the responsibility to you, so you'd better follow
up and do something." The best option is always to do
something quickly and completely to fulfill your respon-
sibility and move the game forward.

What happens all too often is that the ball gets lobbed
into someone's court with no warning and no instruc-
tion. A failure to communicate that you are passing the
ball into someone else's court is dangerous because that
person can assume it is still in your court. Whenever
you give responsibility for part of your call or dream to

someone else, make sure to write out instructions, the results you hope to see, and when you hope to see them.

Remember, it is still your ball, no matter where it is, and God holds you responsible for that call.

To Read: Matthew 6:5-15

Touched by an Angel

*Do not be like them, for your Father knows
what you need before you ask him.*

MATTHEW 6:8, NIV

AN ANGELIC VISITATION announced the birth of two very
important people: Jesus and John, the one who prepared
the way for Jesus. However, the way the angelic message
was received was very different.

Zechariah was doubtful and asked, "How can I be
sure?" The angel picked up on the unbelief. Zechariah
was a priest, an older, mature leader—yet he had doubts.
The angel rebuked him, and Zechariah's unbelief was
silenced—for the entire pregnancy!

Mary was young, very young. She was afraid, like
Zechariah. She also had a question: "How will this be?"
But the angel didn't punish her for the question. Why?

Zechariah knew better. He had represented God
for years. Zechariah was asking for proof—and God
had given him all kinds of proof in the Scriptures.

Zechariah was another Abraham-and-Sarah story, a story he knew well.

Mary believed but wanted to know how it was going to happen because nothing like this had ever happened before.

Has God given you a promise, a promise with proof? Are you still stalling on carrying out the promise? Are you asking God for more and more proof so you don't have to walk by faith?

Choose Mary's heart—believe, then ask God, "How?" How do you want me to react? How do you want me to go forward? How do you want me to step out in faith?

Notes

DAY 24: A FAKE
1. Proverbs 3:25-26, paraphrased.
2. Ephesians 3:12, paraphrased.
3. Philippians 1:6, paraphrased.
4. Hebrews 4:16, paraphrased.
5. 1 John 5:14-15 paraphrased.
6. Hebrews 6:9 paraphrased.

DAY 53: WHAT DO YOU NEED?
1. *Merriam-Webster's Collegiate Dictionary*, 11th ed., s.verse "need."

DAY 64: THE LETTER
1. Excerpt from Pam Farrel, *A Woman God Can Use* (Eugene, OR: Harvest House, 1999).

DAY 65: GO TO COURT
1. Excerpt from Farrel, *A Woman God Can Use*.

DAY 66: REAL FREEDOM
1. Excerpt from Farrel, *A Woman God Can Use*.

Scripture Index

About the Authors

PAM FARREL is a relationship specialist, international speaker, and author of more than 25 books, including the bestselling *Men Are Like Waffles—Women Are Like Spaghetti*. A former pastor's wife and director of women's ministries, Pam is now president of Seasoned Sisters. Pam and her husband, Bill, write a column on relationships and are frequent guests on shows like *Focus on the Family*.

STEPHEN ARTERBURN is the founder and chairman of New Life Ministries—the nation's largest faith-based broadcast, counseling, and treatment ministry. Steve is also the founder of the Women of Faith conferences, attended by more than four million women. Steve is a nationally known speaker and has been featured on *Oprah*, *Inside Edition*, *Good Morning America*, *CNN Live*, and in the *New York Times*, *USA Today*, and *US News & World Report*.